The Past's Threshold

Siegfried Kracauer

The Past's Threshold
Essays on Photography

Edited by
Philippe Despoix and Maria Zinfert

Translations by Conor Joyce

diaphanes

Contents

Philippe Despoix

Kracauer as Thinker
of the Photographic Medium

It is no longer necessary today to introduce Siegfried Kracauer. The major works of this transversal thinker who was at the same time philosopher, novelist, essayist, sociologist and historian, film critic and theoretician of the cinema, have already been re-edited or are accessible in translation. His particular position begins to come into view among the constellation of radical intellectuals from the Weimar Republic who, like Walter Benjamin, Ernst Bloch, Leo Löwenthal or Theodor Adorno, were his partners in discussion. The fact that he is presented here as also a thinker of the photographic medium may come as a surprise given that this volume brings together just five essays and an archive document. This is, in fact, everything that, in his highly varied writings, has directly to do with the photographic medium.

There can be no doubt, however, that in Kracauer's texts published at the turn of the 1920s and the 1930s from his position as an editor of the cultural pages at the daily newspaper *Frankfurter Zeitung*, then in the 1950s during his American period, he sketches out a theorisation of photography that can be described as groundbreaking. But it is also true that most of his works overlap, in more than one way, with this medium of reproduction or that they are even conceived explicitly in relation to it. Facing the mass dissemination

of photography to which he was a witness, Kracauer was one of the first to grasp how necessary it was becoming to develop a critical analysis of photography, and also to learn to think about modernity as a whole via this new form of reproducibility. This reflection continues from his urban essays on the entertainment culture or on the new strata of employees in the Weimar period to his studies on film or on history characteristic of his American work.[1]

Facing Time

Published on the front page of the *Frankfurter Zeitung* in 1927, his first eponymous text on photography belongs to a series of important programmatic essays and will subsequently be included by Kracauer in his collection *The Mass Ornament* (1963).[2] This defining essay weaves together striking themes – the ghost-like character of the reproduced image, its relation to the present, its impact on memory, its consequences for history – all taking their point of departure in the confrontation of two photographic portraits: a contemporaneous one, endlessly reproduced in the illustrated press, of the latest star to be in fashion (Ills. 1–2), and then the old portrait of the deceased grandmother, which is a unique item kept in the family album.[3]

By means of these two photographs of a young person of the same age but taken at two generations' distance, Kracauer homes in on the new relation to time to which the new technique of reproduction contributes. For the latter disrupts not only the relation to the visible world but also the relation to the human sense of time. The revealing and definitive fixing of an *ephemeral* moment from which photography proceeds is for Kracauer one of the sharpest indicators of the crisis in the modern relation to transcendence and to eternal time that religion promised. In the same way as new phenomena like the craze for travel or for exotic dances, for speed or for sports records, photographic reproduction, which favours all these subjects, appears to reveal society's un-mastered anguish in the face of death. The quasi-ritual duplication and the endless dissemination of

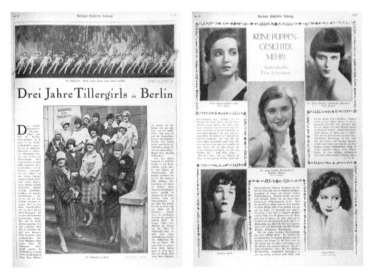

Ill. 1. Drei Jahre Tillergirls in Berlin [Three Years of Tiller Girls in Berlin],
Berliner Illustrirte Zeitung, No. 43, 1927.
Ill. 2. Keine Puppengesichter mehr! Individuelle Film-Schönheit [No More Dolls'
Faces! Individual Beauty at the Cinema], *Berliner Illustrirte Zeitung*, No. 45, 1927.

the same conventional images would seem to be a way of banishing this anguish.

Thus press photography seems to, paradoxically, *obscure* the visible world more than allow it to be observed and known. For Kracauer, the relation to the image that this new type of reproduction induces is of a *ghost-like* kind. In the old album, the deceased grandmother resembles any young girl concealing herself behind her crinoline and the chignons that were fashionable in her day (Ill. 3). Nothing guarantees that the person in the photograph actually is the ancestor in question, nothing, that is, other than the family lore. What shows through is the trace of Time.

But it is no different with the press photo. Of the ephemeral star in vogue today, the success of whose roles depends on her reproduction in the press, we know no other original than the projection of

her image on the cinema screens. The photographic medium unfolds a world of ghost-like copies, of strange phantoms, the originals of which waver irremediably in the face of passing time. Every star of the moment gives way inexorably to the next.

To the infinite accumulation of similar shots, which makes up merely an external and chronological archiving, Kracauer opposes the *inner* memory held of the photographed person, the last image of it. This ultimate image, that he assimilates into a monogram, refers to human finitude. Bergsonian memory can be tacitly made out here, underpinned by qualitative duration (*durée*) and irreducible to the chronometric time to which photography is submitted.[4] It is just such a remembering that Kracauer invokes in the face of the potential loss of the capacity for memory of a humanity that is without transcendental shelter and disorientated among its photographic ghosts.

In the conception of history particular to *historicism*, Kracauer finds a striking parallel for this frightening accumulation of photographic documents which could set its sights on spatial continuity but is only witness to the chronological order within which each document fits. Kracauer's critique is directed precisely at the cumulative and neutralising historical process embodied by the then dominant current of historiography that he associates in the twenties with, above all, Dilthey's conception of the *Geisteswissenschaften*. Kracauer contrasts his negative vision of a history torn between catastrophe and utopia with series of events in their purely temporal succession, with this sum of "photographs of the time" of which the biographical enterprises around Goethe are emblematic.[5] The utopia of freed consciousness to which the essayist refers he sees embodied in Kafka, but he also sees it finding a setting in the oneiric game of fragmentation and re-composition particular to the cinematic medium.

It is significant that Kracauer does not make artistic photography the centre of his analysis but, instead, the trivial shot printed in the newspaper. He thereby underlines the fundamental characteristic of this medium as a form of hybrid reproduction. The portrait of the

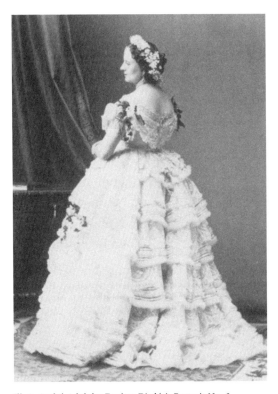

Ill. 3. André-Adolphe-Eugène Disdéri, Portrait No. 3
taken from Mlle Hortense Schneider en huit poses
[Miss Hortense Schneider in Eight Poses], 1860.

star cannot be understood in an individual way without consider-
ing the *intermedial* chain of duplication of which it is only one ele-
ment, a chain that associates cinematographic filming, set photos,
photo-reportage and reprographic printing. Kracauer approaches
photography primarily as a vector of mass culture, to the very degree
that it forms one of that culture's main bases and disseminates its
leitmotivs.

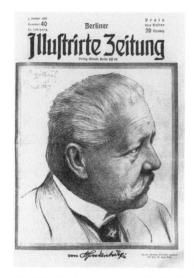
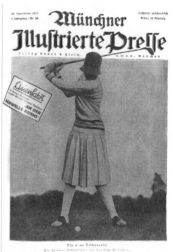

Ill. 4. Von Hindenburg, cover of the *Berliner Illustrirte Zeitung*, No. 40, 1927.
Ill. 5. Die neue Silhouette. Die Berliner Golfspielerin Frl. Tag beim Driveschlag
[The New Silhouette. The Berlin lady golfer Miss Tag hitting a drive],
cover of the *Münchner Illustrierte Presse*, No. 30, 1927.

The cinema star reproduced in the newspaper could just as well
be a variety-show dancing girl, the equivalent of one of the anony-
mous Tiller girls. This famous troupe that raised its leg like a single
collective body acted as a focal point in the major essay "The Mass
Ornament" that had been published shortly before by Kracauer and
in which he analysed the new modern mass rituals that were then
breaking out: review parades, sports events, gymnastic displays,
etc.[6] A brief look at the illustrated press of this period, beginning
with *Berliner Illustri[e]rte Zeitung* which was a leading title, shows
that all his chosen topics are regularly invoked there: the starlet
posing on the beach, a speedboat race on the Lido, reports on the
Tiller girls, portraits of successful actresses, photos of sportspeople
in action or of exotic beauties, but also advertising and political stag-
ings, such as of Marshall Hindenburg (Ills. 4–5 and 6–7).[7] Kracauer's

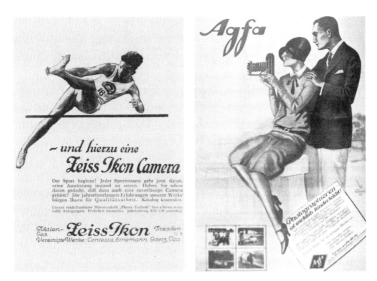

Ill. 6. Zeiss-Ikon advertisement, *Berliner Illustrirte Zeitung*, No. 14, 1927, p. 541.
Ill. 7. Agfa advertisement, *Berliner Illustrirte Zeitung*, No. 29, 1927, p. 116.

critical essay, which he publishes in a daily newspaper that does not carry illustrations, presents itself as a fictional assemblage of these photographic commonplaces propagated by the new popular press.

The essay is conceived and written in the period when his friend Walter Benjamin is also taking a close interest in the illustrated magazines. Benjamin comes to the defence, not without irony, of the *Berliner Illustri[e]rte Zeitung* in his sketch "Nothing against the Illustrated Press". Benjamin insists, against literary critics who are too timid, on this press' importance in view of the undifferentiated mass of readers it reaches and of the documentary character of its iconography that sometimes even has avant-garde features.[8] Benjamin will, moreover, directly quote Kracauer's essay in his own "Little History of Photography" of 1931, picking up his friend's conjunction

between the record of a sportsperson, the time lag of a photographic pose and reproduction in the illustrated magazines.[9] The similarity of their preoccupations with the new forms of entertainment cannot be underlined enough here.

Without yet knowing it, Kracauer's concerns are close to those of Aby Warburg who was at the same time turning his attention to photography in the illustrated press. The analysis of its specific iconographical formulae is, for Warburg, an explicit part of the "mission" for his *Kulturwissenschaftliche Bibliothek*. During his work on the atlas *Mnemosyne* (1927–29), Warburg will not hesitate to juxtapose photographs of sports, recreational or political events cut out of the newspapers with sculptural forms and settings from Antiquity.[10] These examples, that could be multiplied, outline at the end of the 1920s the context of a multiple interrogation – of which Kracauer was one of the main protagonists – on the effects of the generalisation of photographic reproduction on cultural memory.

On Yesterday's Border

The critique of the quasi-cultic function of photography in the illustrated magazines soon gives way, however, to an analysis of the affinities specific to the medium. Three exhibitions held in Berlin at the beginning of the 1930s give Kracauer, who has in the meantime become a very well respected film critic, the chance to clarify the approaches and qualities specific to the new technique. "On Yesterday's Border" is based on his visit to the Berlin permanent exhibition *Film- und Photoschau* that opened in the summer of 1932 and was envisaged as a provisional prefiguration of a future museum of photography and cinema.[11]

From the magical drums and the flip books, which are moments of transition between the still image and the animated one, to the bioscope of the Skladanowsky brothers, German competitors of the Lumières, all the archaic techniques of the illusion of movement which were a big attraction of the popular fairs, capture the attention

Ill. 8. Bioscope of Max and Emil Skladanowsky, 1895.
Ill. 9. Film roll taken from the first film by the Skladanowsky brothers, 1895.

of the critic (Ills. 8–9). Kracauer puts them in historical perspective to conceive as a continuous series photography, chronophotography, the very earliest cinema, silent movies and even recent sound films. He notes, nevertheless, how the first silent fictions, which as early as the 1910s transposed popular tunes and themes from pot-boilers and which made modern stars of actresses like Henny Porten, only have an unintended comic effect in hindsight.[12]

But it is the section dedicated to the first photographic experimentations of Niépce which allows Kracauer to take up again his reflection on the temporal dimension that is peculiar to this technology. Thus, a mere window captured on bituminous paper from the beginnings of heliography – the paper's conservation does not even seem assured – is revealed to be not only a paradigm of this

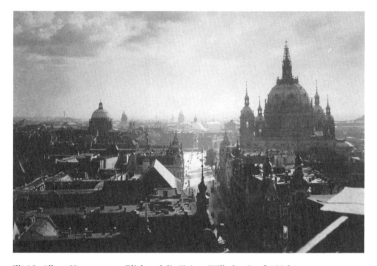

Ill. 10. Albert Vennemann, Blick auf die Kaiser-Wilhelm-Straße Richtung
Lustgarten [View on Kaiser-Wilhelm Street in the direction of the Lustgarten],
ca. 1925.

archaic phase but of photography as a whole. While unable to make
people believe in the eternity of the film star reproduced in the
newspapers, the photographic medium seems able to safeguard the
transient character of objects destined to disappear. This distinction
indicates how much photography materialises, in Kracauer's eyes,
a modern aesthetic of the ruin.

"Photographed Berlin", a miniature in the form of an exhibition
review, echoes this. The exhibition, from the end of 1932, on the
landscape of Berlin, allows Kracauer to clarify how much "that which
is known and has already vanished" is the area where photography
asserts its singularity. The shots of Albert Vennemann – who had
published in the review *Querschnitt* among other places and whose
work made up the exhibition – refer for Kracauer as much to the
ephemeral nature of the urban landscape as they do to the process
of his own memory, as city-dweller, becoming history (Ill. 10). The
photography seems to fall within a natural history – a symbol for

which could be the Tiergarten park, marked as it is by the heterogeneous temporalities of nature and civilisation. As a memory image, photography can only stay on "yesterday's threshold" beyond which it loses its evidence and becomes a historical document.

The series of articles of this period concludes with "Note on Portrait Photography", published in February 1933, a few weeks before Kracauer hurriedly left Berlin where the Nazis had taken power. The portrait appears to him to be the area *par excellence* in which the new technology must affirm its difference from traditional media which, like painting, had given the genre a special status. The corresponding exhibition, probably of modest dimensions, is hardly mentioned, serving as a pretext for a more developed reflection on the photographic values specific to the human face. Only a short time before, August Sander had, with his *Antlitz der Zeit* (1929), transformed the portrait into an exploration of social physiognomy, and Walter Benjamin had just praised it in his "Little History of Photography".[13] Similarly, Helmar Lerski, to whose experimentations Kracauer will later return, had demonstrated this orientation with his *Köpfe des Alltags* (1931), a series of anonymous heads taken in their daily environment and defined only by their profession.[14] In the same vein is a kind of portrait with minimal stylisation which is an example for Kracauer of the specific relations characterising what he will soon theorise as "the photographic approach".

Towards a Photographic Approach

Kracauer's exile in France, in the thirties, will not give him the opportunity to publish on photography. The latter occupies, nevertheless, a pivotal role in what is known as the "Marseille manuscript" of 1940, the first draft of what will become his final theory of film. He refers early in the manuscript to the paradox that photographic technology is born from the interest in movement, and he notes the central importance in the transition towards film of chronophotography – meaning Muybridge or Marey – registering a

horse's gallop.[15] What is for Kracauer characteristic of the medium from its beginnings is its "indifference towards subject matter", its non-anthropocentric character that we find at the heart of his "theory of the instant photograph":

> beginning from immediate perception, two paths lead in opposite directions [he writes]: the first leads to the image (...), the second to the INSTANT PHOTO. The latter is the opposite of an image (...) and all the more characteristic in that it captures just any moment (...) that it freezes complexes that are *not* intentional compositions.[16]

It is this "tendency towards the instant photo" – this exact radical formulation will not be used again – that forms, in this Marseille manuscript, the moment of articulation between photography and film.

So at the moment when Kracauer is elaborating the very basis of his cinematographic theory, photography becomes once more for him an unavoidable pathway. The writing of *Theory of Film*, put off numerous times, will stretch over twenty years and the work will only be published in the United States in 1960. But it is not by chance that the first preliminary publication from this *magnum opus* is devoted to photography. This is the article "The Photographic Approach", published in 1951 in the lavishly illustrated *The Magazine of Art,* and the last text presented here with the original photographs chosen by the author.

Written in English, which is now his adopted language, this singular essay is an initial, partial version of the introductory chapter to *Theory of Film*. It is imbued with Kracauer's new American context, in particular with his exchanges with Beaumont Newhall, the curator of numerous exhibitions at the Museum of Modern Art and one of the first historians of photography. Kracauer borrows a good deal of material from him, taking it from, among other places, his fundamental study "Photography and the Development of Kinetic Visualization".[17] But the essay is also witness to a decisive "rediscovery" of Proust and of the central place that photography occupies

in *Remembrance of Things Past*. It is a theme that may well have been the subject of discussions in Paris, and even in Marseille, with Benjamin who had translated two of the volumes.[18] It is from this point on that Proust takes on the role of theoretical interlocutor occupied implicitly by Bergson in the first essay of 1927. In the staging of the Proustian novel, the instant photograph – that of the grandmother in the narrator's mind – appears as an instrument of complete *estrangement* of the subject, as a screen hindering the revelations of involuntary memory. By borrowing Proust's terms but inflecting the values given to them, Kracauer is able to affirm, in an insight complementary to Proust's, that photography is the medium of access to the visible, and to material existence. Photography, by virtue of its involving a fundamental alienation of human vision, is for Kracauer an implement of concrete knowledge.

The main concepts that will structure not only the first chapter on photography but, with some variations, all of *Theory of Film*, are already set out in this new essay. Phenomena particularly suited to being rendered by the medium have for Kracauer to do with a reality without artifice, that is unstaged. They derive from the fortuitous, from the indeterminate, from endlessness. Kracauer constructs a basic tension between, on the one hand, the approach he describes as photographic, which is comparable to an imaginative reader trying to discover the hidden layers of a text and, on the other hand, the approach of the traditional artist who, passionately wanting to express his vision, tries to realise it using photography.[19]

Kracauer makes visible this polarity, which inhabits the medium from its beginnings, by his choice of photographic documents, by, for example, counterposing Talbot's *The Open Door* from the very beginnings of photography with Adam-Salomon's self-portrait inspired by the pictorial tradition.[20] It is not an accident that the names of the authors – some of them eminent – of the photographs informing the page layouts are often not even quoted. He is not primarily interested in the photographers as artists for their style, but, rather, in the defining tension revealed in their shots between an expressive tendency and a realist one. It is, moreover, remarkable

that the series of photographs that he proposes as counterpoint to his argument, set out all of the realms of nature to the point where differences between them begin to blur. There are shots where minerals, even the urban landscape, become abstract (Weston and Moholy-Nagy), there is a landscape of stones "humanised" by a rail-track that splits the horizon (Russell), and a view of children playing in the remains of ruined buildings (Cartier-Bresson). The division between the animal and the botanical begins to blur (Eliot Porter), and there is the closeness between the botanical and the mineral in the interlacing of roots captured by Atget.[21] This sober series appears to be a summary of the qualities that are specific to the medium in its affinity with the visible world. A work by Atget concludes the series, and a photograph by him will also be used to open the iconography of *Theory of Film*, of one of those deserted Parisian streets already admired by Benjamin (Ill. 11).[22] This kind of photograph embodies the estrangement of the human gaze in which Kracauer sees the origin of the aesthetic *and* cognitive dimensions that are constitutive of the medium. This point, that is fundamental, will lead him to claim that we are dealing with a technology at one remove from the traditional artistic domain, a technology that even displaces the very idea of art – "art with a difference".[23]

History, Photography, Autobiography

The texts of Kracauer's American period are then simultaneously continuous with, and a reversal of, the texts of the Weimar period. The endless repetition of the star's portrait in the newspapers brought with it the danger of people being blinded to disenchanted reality and of them conjuring away death, now that transcendence no longer ministered for death. The defence of a photographic approach as a means of estrangement grounds from the beginning of the 1940s a salutary exploration of the real world. Carlo Ginzburg has emphasised in a penetrating commentary to what extent "photography which was for Kracauer in 1927 'the sign of the fear of death' became

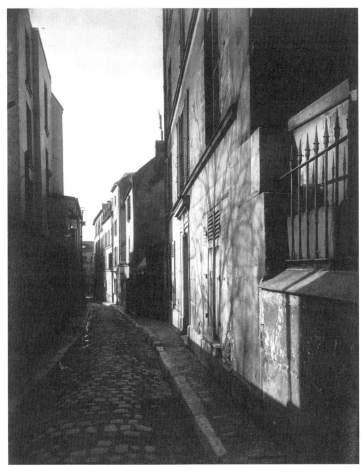

Ill. 11. Eugène Atget, Rue Saint-Rustique, 1922.

through Proust the tool that enables one to transcend this fear, to look death in the face."[24]

The failure to recognise the loved one on a photograph, which pointed for the French writer to an anticipated death or to a real mourning suddenly "opens the spectator's estranged gaze to the illumination of knowledge."[25] Whereas at the end of the twenties the ghost-like character of photography called, in Kracauer's eyes, for redemption by the utopian power of the cinematographer, the two technologies are now thought of in a material continuity that is positively viewed. By subtracting man for one instant from his language, the photographic medium makes him face his own finitude, that is to say, his own historicity. This touches on one of the epistemological foundations of Kracauer's final work *History. The Last Things before the Last* (published posthumously in 1969) which was undertaken as a complementary project to *Theory of Film* and which systematically weaves together photographic media and the theory of historiography. At the same time, the difference of his approach to the reproductive technologies when compared with that of the Frankfurt School, particularly with his friend Adorno, becomes even clearer. Adorno, indeed, will reproach Kracauer for this affirmation of positivity. Far from restricting himself to a critique of ideology, the theory of the later Kracauer has more important analogies with the specifically temporal dimension that Barthes, deconstructing his own semiology a generation later, would discover by way of Proust in photography.[26]

This collection of essays ends with a strange document. It is a series of photos of a hypothetical "Curriculum Vitae in pictures" that was planned, it seems, by Kracauer. But it is difficult to establish if it was ever carried out. Is this an irony of history? The envelope carrying this title is empty now, although a considerable number of disparate photographs are stored in the archives.[27] The name of the project bears unambiguous witness to the continual, indeed concrete, nature of the importance of photography for Kracauer.

His reflections on the hitherto uncharted relation to time and memory inaugurated through the medium came side by side in the 1920s with a virulent critique of the biographical *genre* as a new literary fashion that revealed a double crisis: of the novel and of historiography. In his American period, an analysis of photography opens, as we have seen, his major work on the cinematic medium, and photography continues to provide the analogical crux that is epistemologically central to his last unfinished work on history, its presuppositions and its modes of writing.[28]

Does the project of a curriculum in pictures constitute the outline of a photographic autobiography? If so, it would be at the meeting-point of two lines of thought particular to Kracauer, that of autobiography as a legitimate form of "biography of a society" and that of the structural affinity between photography as a medium and historical material.[29] The project is all the more surprising when one remembers his strong plea for "exterritoriality" – the city of New York was the symbol of this for him – or his fierce desire to extricate himself from any public "chronological labelling".[30] This refusal of any point of anchorage, the affirmation of a certain spatio-temporal state of floating that also characterises the historian's position, would seem to be stymied by the assemblage of a set of photographs capturing with precision his changing physiognomy at certain times and at certain places. Unless it was envisaged as a posthumous album, as a physical trace, fragmentary and incomplete, of that which remains after death, or envisaged even, more radically, as a series of places that were the frame of his existence.

We will probably never know if this project was conceived as a complement to those "memoirs in the grand style" that Kracauer mentioned – not without a tone of scepticism – in his correspondence at the beginning of the 1950s.[31] Nor will we ever probably know if this uncertain curriculum in pictures came later to take the place of memoirs following his reflections on the historiographical value of the photographic medium, nor whether it is his wife Elisabeth Kracauer – author of most of the photographs of him subsequent

to their marriage – who took it upon herself to carry on with the project after his death.

These archive photographs reveal to us neither the personality of Kracauer nor his biography. But through the chance of their having been conserved and by virtue of their imperfect state, they bear witness to disparate episodes of a journey through the twentieth century, episodes that are revealed in the density of the successive photographic technologies and practices, from the studio pose to the snapshot, from the fragile glass plate to the Polaroid. They seem to have been left to us like raw material that its own theory would alone be capable of deciphering. Maria Zinfert proposes an imagined and provisional reconstruction of the project at the end of this volume.

Essays on Photography

Freitag, 28. Oktober 1927 15 Pfg. Erstes Morgenblatt 72. Jahrgang Nr. 802

Frankfurter Zeitung
und Handelsblatt.

Die Todesstrafe.

Von Dr. Hirschberg (München).

Wirtschaftslage und Anleihepolitik.

Reichswirtschaftsminister und Reichsbankpräsident vor dem Haushaltsausschuß.

(Drahtbericht der „Frankfurter Zeitung")

Der Sitzungsbericht.

Die Photographie.

Von Siegfried Kracauer.

Photography

In the time of Schlauraffen I went forth and saw Rome and the Lateran hanging by a small silken thread, and a man without feet who outran a swift horse, and a keen sharp sword that cut through a bridge.

Grimm's Fairy Tales[1]

1

This is how the *film star* looks. She is 24 years old. She is on the cover of an illustrated magazine standing in front of the Excelsior Hotel on the Lido. We are in September. If one looked through a magnifying glass, one could recognise the grid, the millions of tiny dots that form the star, the waves and the hotel. But the subject of the picture is not the network of points; it is the living star there on the Lido. The time: the present. The accompanying text calls her demonic; our demonic star. Despite this, she is not devoid of a certain expression. The tomboy hairstyle, her bewitching way of holding her head and the twelve eye-lashes on the right and on the left – all the details painstakingly itemised by the camera – are at their appointed place in space, making a flawless appearance. Everyone is delighted to recognise her, for everyone has already seen the original on the screen. The photograph is such a good likeness that

27

she cannot be confused with anyone else, even if she is maybe only the twelfth part of a dozen Tiller Girls.[2] Dreamlike, there she stands in front of the Excelsior Hotel, which basks in her fame, a creature of flesh and blood, our demonic star, 24 years of age, on the Lido. We are in September.

Did the *grandmother* look like this? The photograph, which is over 60 years old and already a photograph in the modern sense, shows her as a young girl of 24. As photographs capture likenesses, this one too must have been how she looked. It has been produced with care in the studio of a court-licensed photographer. But if the oral tradition were missing, it would not be possible to reconstruct the grandmother from the picture. The grandchildren know that, in her later years, she lived in a narrow little room that had a view of the old, historical, city centre; they know that, for the sake of the children, she made soldiers dance on a glass plate. They know a wicked story from her life and know two remarks credited to her, which change a little from one generation to the next. For the photograph to be of the same grandmother of whom one has held on to this little, a little that will also perhaps be forgotten, credence must be given to the parents who claim that they knew it directly of the mother. Witnesses' testimony is uncertain. In the end, it is not the grandmother who is represented in the picture but her girlfriend whom she resembled. Contemporaries do not exist anymore. But where is the likeness? The original rotted away a long time ago. The image, now darkened, has so little in common with the remembered features that the grandchildren force themselves to believe with astonishment that this is an encounter with a female ancestor who has been handed down to them in this fragmentary way. So, good, it is the grandmother, however, in reality, it is any girl of 1864 chosen at random. The girl smiles on, always with the same persisting smile, which stands still, without reference anymore to the life from which it has been taken. The likeness is no longer of any use. Tailors' dummies in hairdressers' shops smile in just such a stiff, unending way. The dummy is not contemporary; it could be in a museum in a glass cabinet with others of its kind, a cabinet that

might well be labelled 'Dress, 1864'. The dummies are there because of the historical costume, and the grandmother in the photograph is also an archaeological dummy serving to present the dress of the period. So that was how one dressed in those days: with a chignon, in a narrow corset, in crinoline and a little Zuave jacket. Before the grandchildren's eyes, the grandmother is dissolving into old-fashioned details of fashion. The grandchildren laugh at the attire which, with the disappearance of its wearer, commands on its own the scene of the action, an external decoration that has become something autonomous. The grandchildren have no respect, and nowadays young girls dress differently. They laugh and they get the creeps at the same time. For via the ornamental side of the dress, through that from which the grandmother has disappeared, they think that they catch sight of a moment of past time, that time that passes without return. It is true, time is not photographed along with the smile or the chignon, however the photograph, so it seems to them, is a presentation of time. If only photography would bestow permanence on them, they would not endure at all beyond mere time — rather time would make pictures out of them.

2

"From the Early Period of Goethe's and Karl August's Friendship" – "Carl August and the Election of the Coadjutant for Erfurt 1787" – "The Visit of a Bohemian to Jena and Weimar (1818)" – "Memoirs from a Weimar Secondary School (1825 to 1830)" – "A Contemporary Account of the Goethe Celebrations of 7 November 1825 in Weimar" – "A Rediscovered Bust of Wieland by Ludwig Klauer" – "Plan for a National Goethe Memorial in Weimar" – The herbarium in which these and other studies have grown is the Goethe Society's *Jahrbücher*, a series which can continue in principle without end. To make laughable Goethe philology, which deposits its compounds in the volumes, would be all the more pointless given how it is wishing goodbye to this life that it has taken up, whereas the false glamour

of the numerous monumental works on the figure of Goethe, on his being and personality, has hardly been laid bare. The principle of Goethe philology is that of the *historicist* thinking that has become dominant at approximately the same time as modern photographic technology. Its representatives[3] assume, overall, that one can explain any phenomenon purely by tracing its origins. They believe in any case that historical reality is grasped when they have completely re-constituted the succession of events in their temporal sequence. Photography provides a space-continuum; historicism would like to fulfil the time continuum. The entire mirroring of the intra-temporal course of a period contains, according to historicism (*Historismus*), the meaning of everything that has happened in that time. If, in the representation of Goethe, were missing the intermediate links that are the election of the co-adjutant for Erfurt or the memoirs of the Weimar secondary school pupil, the representation of him would be lacking in reality. For historicism, it is a matter of the photography of time. What could correspond to its photography of time is a huge film which would depict the processes linked together in it from all sides.

3

Memory incorporates neither the total spatial nature of a state of affairs nor its total temporal course. Its recordings are, compared to photography, full of gaps. That the grandmother was once caught up in a wicked story which is always being retold, for there is an unwillingness to speak about it, this fact will not mean much from the standpoint of the photographer. He knows the first little wrinkles on her face, he has noted every datum. Memory does not pay heed to dates, it skips over the years or it increases the span of time. The selection of features that are brought together by memory must seem arbitrary to the photographer. The selection must be made in this and not that way because memory's dispositions and purposes demand the repression, falsification and accentuation of certain parts of the

subject; a spurious infinity of reasons decides on what remains to be filtered. Whatever scenes a person happens to remember, they mean something that relates to the person without necessarily having to know what they mean. The scenes are preserved due to what they mean for that person. So they are organised according to a principle which differs in its essence from photography. While photography grasps what is given as a spatial (or temporal) continuum, memory images preserve the given in so far as it means something. Since what is meant is disclosed just as little in the purely spatial context as it is in the purely temporal one, memory images are out of kilter with photographic reproduction. If they seem to be a fragment from the point of view of photography – a fragment because photography does not incorporate the meanings to which they relate, and directed towards which they cease to be a fragment – so, in reverse, from the viewpoint of memory images, photography seems a jumble of things made up in part of detritus.

The meaning of memory images is tied to their truth content. As long as they are tied to the uncontrolled life of the drives, there lives within them a demonic ambiguity. They are as opaque as frosted glass through which a shimmer of light barely penetrates. Their transparency grows to the extent that knowledge clears away the vegetation of the soul and sets limits on natural compulsions. Truth can only be found by a freed consciousness, which is able to have the measure of the demonism of the drives. The features remembered by this consciousness are related to what is cognised as true, which is revealed in the features or may be excluded by them. The image in which these features are to be found, stands out from all other memory images, for it does not preserve as they do an abundance of opaque memories but preserves contents recognised as true. All memory images need to be reduced to this one image, that can be called for good reason the last one, for only in it does what is unforgettable linger. The last image of a person is its genuine "*history*". From it, all marks and particularities fall away that do not relate in a meaningful sense to the truth as cognised by a freed consciousness. How it is represented by a human being depends neither

purely on its natural constitution nor on the apparent coherence of its individuality; only bits of these contents go into the history of the human being. The history is like a *monogram* that condenses a name to a drawn line, which has meaning as an ornament. The monogram of Eckart is fidelity.[4] Great historical figures live on in their legends which, however naïve, seek to preserve their genuine history. In proper fairytales, fantasy has recorded typical monograms in an allusive way. Beneath a human being's photograph, its history is buried like under a blanket of snow.

<div align="center">4</div>

Eckermann, describing a Rubens landscape shown him by Goethe, remarks to his surprise that the light in it seems to come from two opposite sides "which is quite contrary to nature". Goethe answers him, "It is by this that Rubens proves himself great, and shows to the world that he, with a free spirit, stands *above* nature, and treats her comfortably to his higher purposes. The double light is certainly a violent expedient, and you certainly say that it is contrary to nature. But if it is contrary to nature, I still say it is higher than nature; I say it is the bold stroke of the master, by which he, in a genial manner, proclaims to the world that art is not entirely subject to natural necessities, but has laws of its own."[5] – A *portraitist* who subjected himself thoroughly to "natural necessities" would make at best photographs. In a certain epoch that had begun with the Renaissance and is now perhaps coming to a close, the "work of art" certainly stays close to nature, the particularities of which are being revealed more and more in this epoch; but the "work of art" is directed, going through this very nature, towards "higher purposes". It is cognition in the material of colours and of contours, and the greater the work, the more it approaches the transparency of the last memory image, in which the features of the "history" come together. A man whose portrait was being painted by Trübner[6] asked the artist not to forget the folds and wrinkles on his face. Trübner

<div align="center">32</div>

pointed to outside the window: "A photographa' lives over there. If folds and wrinkles is what you want, then you'll have to get 'im to come, he'll make everything perfect for you. I pain' history." For the history to be represented, the mere surface connections that photography offers must be destroyed. For in the work of art, the meaning of the subject becomes a spatial appearance, while in photography it is the spatial appearance of a subject that is its meaning. The two appearances, the "natural" one and the one cognised as true, are not commensurate. In giving up the former for the sake of the latter, the work of art negates at the same time the *likeness* for which photography aims. Photographic likeness concerns the subject's appearance which does not betray how the subject would be revealed in cognition; the work of art, in contrast, only conveys what is transparent in the subject. In this it is like a magic mirror which does not reflect back to a human being inquiring of how it looks but how the person wishes to be or is deep down. The work of art also deteriorates over time; however, from its decomposed elements, there emerges what was meant, while photography stows the elements away.

Until well into the second half of the last century, the photographic procedure was frequently practiced by former painters. There corresponded to the not yet thoroughly depersonalised technology of that period of transition, a spatial environment in which traces of meaning were capable of holding on. With the increasing detachment of the technology and the simultaneous withdrawal of meaning from its subjects, *artistic photography* loses its rights. It flourishes not in making works of art but in their imitation. Portraits of children are Zumbusches,[7] and Monet was the godfather of landscape impressions. Compositions that do not go beyond the deft following of familiar styles fall short precisely in the representation of the rest of nature, of which the developed technology was to a certain extent capable. Modern painters have assembled their pictures from photographic fragments, to underscore the juxtapositions of reified appearances, which juxtapositions get assimilated in spatial relations. This artistic intention is contradicted by that of artistic

photography. This latter does not work from the areas that are in keeping with the photographic technology but rather its intention is to dress the technical reality in a stylish way. The artistic photographer is an artist dilettante who copies an artistic style after the removal of its content, instead of simply capturing the absence of content. Similarly, rhythmical gymnastics also wants to involve the soul, of which it knows nothing, and this gymnastics concurs with artistic photography in also striving to take possession of the higher life in order to elevate an activity, that is at its most elevated when it finds a subject suitable to its technical capacities. Photographer-artists work with the mentality of those social powers that are interested in the appearance of the intellectual, because they are fearful of what the intellect is. The latter might blow up the foundations the appearances of which work as a distortion. It would be worth the effort to uncover the close relations between the existing social order and artistic photography.

5

Photography does not preserve the transparent features of an object or person but records it from whatever position as a spatial continuum. The ultimate memory image outlasts time because it is unforgettable; the photograph, which does not mean or conceive the memory image, must be assigned essentially to the instant of its emergence. "The essence of film is, to a certain extent, the essence of time",* E.A. Dupont[8] remarks in his book on the average film, the theme of which is the ordinary surroundings that can be photographed (quoted from Rudolf Harms' *Philosophy of Film*). If, however, photography is a *function of passing time*, then its factual

* Ewald André Dupont, *Wie ein Film geschrieben wird und wie man ihn verwertet*, Berlin, Kühn, 1919, p. 15, quoted in Rudolf Harms, *Philosophie des Films*, Leipzig, Meiner, 1926, p. 142.

meaning will change depending on whether it belongs to the realm of the present or to some period of the past.

Today's photography which depicts appearances familiar to the *contemporary* consciousness, provides limited access to the life of its original subject. It records each time a superficial state that, in this period of its supremacy, is as understood a means of expression as is language. A contemporary believes that in the photograph he catches sight of the film star herself, not just her tomboy haircut or the way she holds her head. Admittedly, he would not be able to judge her from the photograph alone. But luckily the star dwells among the living, and the cover of the illustrated magazine is fulfilling the task of recalling her bodily reality. This means that today's photography is acting as an intermediary; it is an optical sign for the star and it counts as cognition of her. Whether her decisive characteristic is her demonic quality may, in the end, be doubted. For the demonic here is less something imparted by the photograph than it is the impression of the cinema-goers who experience the original on the screen. They accept it as the representation of the demonic; fine. It is not because of its likeness to the star but *despite* of it, that the photograph denounces the demonic. The latter belongs for the time being to the still unstable memory image of the star, to which the photographic likeness does not relate. The memory image created out of our experience of the celebrated star, breaks through the wall of likeness into the photograph and thus lends some transparency to it.

When the photograph ages, the direct relation to the original is no longer possible. The body of a dead person seems smaller than its living form. An *old* photograph also appears to be smaller than a present-day one. Life has retreated from it, that life of which the spatial appearance covered the bare spatial configuration. Memory images behave in the opposite way to photographs, the former enlarging themselves to be the monogram of the remembered life. The photograph is the residue that has fallen from the monogram, and its value as a sign diminishes from year to year. The truth content of the original remains within its history; the photograph includes the deposit that history has eliminated.

When the grandmother is no longer encountered in the photo-graph, the picture taken from the family album must collapse into its details. While the gaze can wander from the star's tomboy haircut to her demonic nature, from the nothing that is grandmother, the gaze is referred back to the chignon, to the details of fashion holding one's attention. Photography's dependence on time corresponds exactly to the time dependence of *fashion*. As fashion has no meaning other than its being the contemporary human husk, modern fashion is translucent and the old one abandoned. The dress worn with the narrow corset juts from the photograph into our time like a patrician mansion from earlier times that is exposed to destruction because the centre has been moved to another part of the town. Members of the lower classes usually settle into such buildings. To acquire the beauty of the ruin, very old attire needs to lose all touch with the present. Recently worn attire has a comic effect. The grandchil-dren make fun of the grandmother's 1864 crinoline, prompting the thought in them that modern girls' legs might be hidden under it. The look of the recent past, with its claim to be alive, is more lifeless than a look of long ago, the meaning of which has changed. What is comic about the crinoline is explained by the impotence of its presumption. In the photograph, the grandmother's attire is recog-nised as an abandoned remnant that would like to claim continued existence. The attire is reduced to the sum of its parts, like a corpse, and it imposes itself as if there were still life in it. A landscape in old photographs, and every other subject in them, are also period attire. For it is not the features intended by the freed consciousness that are preserved in such an image. It represents relations from which that consciousness has withdrawn, and includes contents that have shrivelled without wanting to admit it. The more consciousness removes itself from natural bonds, the smaller nature grows. On old engravings aiming at photographic fidelity, the hills of the Rhine appear as mountains. Because of the technical development, they have been since relegated to tiny slopes, and the delusions of gran-deur of those grizzled views is a little ridiculous.

The ghost is funny and dreadful at the same time. It is not just laughter that answers the outdated photograph. It represents the mere past, but the remains were once the present. The grandmother was a person and to this person there belonged the chignons and a corset and the High Renaissance chair with its twirled stiles. Ballast that did not depress but was taken along without thinking. The picture haunts the present now, like the lady of the castle. It is only in places where a bad deed has been committed, that apparitions move about. The photograph becomes a ghost because the costume-dummy was once alive. It is proven through the picture that the strange accoutrements were incorporated into life as self-evident accessories. These things, whose lack of transparency is experienced in the old photograph, were once inextricably mixed with the transparent features. The wicked link that persists in the photograph awakens a shudder. Such a shudder is produced in a drastic way in the film scenes of the pre-war period that were presented in the Parisian avant-garde cinema Studio des Ursulines[9]; the scenes show how features, stored in memory images, are caught up in a long disappeared reality. The replaying of old hit-songs or the reading of once written letters also conjures up afresh, like the photographic portrait, the unity that had fallen apart. This ghostly reality is *unredeemed*. It consists of parts in space, the connection between which is so little necessary that one could conceive of the parts being also ordered differently. It had once clung to us like our skin, and this is how our property still clings to us nowadays. We are held in nothing, and photography gathers fragments around a nothing. When the grandmother stood before the lens, she was for a second present in a space continuum that offered itself to the lens. But what was made eternal was just this aspect, instead of the grandmother. The viewer of old photographs feels a shiver. For they make present not the knowledge of the original sitter but the spatial configuration of a moment; it is not the human being that emerges from the photograph but rather the sum of everything that can be subtracted from that being. The photograph destroys the human being, by picturing it, and were the being and photograph to become

one, the being would not exist. Recently, an illustrated magazine, under the title 'The countenance of the famous. Thus they once were and thus are they now!', juxtaposed childhood shots of well-known personalities with shots of them in their maturity. Marx as a boy and Marx as a Centrist leader,[10] Hindenburg as lieutenant and our Hindenburg.[11] The photographs stand beside one another like statistical reports and it is no more possible to foresee the later image in the earlier one than it is to reconstruct the latter from the former. The statement that the registers of optical inventory belong together is to be taken on trust. The features of human beings are contained in their "history" alone.

<p style="text-align:center">6</p>

The newspapers illustrate their texts more and more, and what would a magazine be without image material? The irrefutable proof of the very marked validity of photography of the present day is provided above all by the increase in the number of *illustrated magazines*. In them are gathered together all phenomena, from the film star onwards, that are within reach of the camera and the public. Babies interest the mothers, while the young men are captivated by groups of beautiful girls' legs. Attractive girls love to look at sports and theatre stars who stand on the gangway of the ocean liner when they are travelling to distant lands. In those distant lands, conflicts of interests are fought out. However, interest is not directed at them, but on the cities, the natural disasters, the leading intellectuals and politicians. The congress of the League of Nations is meeting in Geneva. It serves to show Messrs. Stresemann and Briand[12] in conversation in front of the hotel entrance. The new fashions must also be spread, otherwise the attractive girls do not know in the summer who they are. The fashion beauties appear with young men at society events, in distant lands there are earthquakes, Mr. Stresemann is sitting on a terrace lined with palm trees, and for the mothers there are our little ones.

The intention of the illustrated newspapers is the complete repro-
duction of the world that is accessible to the camera; they record the
spatial imprint of people, circumstances and events from all possible
perspectives. Their method corresponds to that of the weekly film
newsreel;[13] it is a sum of photographs, whereas for real film, a photo-
graph only serves as a means. There has never been a time that has
known so much about itself, if knowing about oneself means having
a picture of things that is similar to them in a photographic way.
As topical photographs, most pictures in the illustrated newspapers
refer to subjects which exist in reality. The images are therefore at
bottom signs, which help recall the original that should be recogn-
ised. The demonic film star. In reality, however, a reference to the
originals is not intended at all by the weekly ration of photographs.
If the weekly supply were to serve as a support for memory, then
memory would have to determine its selection. Yet the flood of pho-
tos sweeps away memory's dams. The onslaught of the collections
of images is so powerful that it threatens to destroy the awareness
of important features that perhaps exists. Works of art suffer this
fate through their reproduction. The saying is true for the dupli-
cated original: in for a penny, in for a pound. The original, instead
of appearing from behind the reproductions, tends to disappear in
their multiplicity and to live on as art photography. In the illustrated
publications, the public sees the world, the perception of which is
hindered by these very publications. The spatial continuum from the
camera perspective overtakes the spatial appearance of the cognised
subject, and the likeness with the latter blurs the contours of the
subject's "history". There has never been a time that has known
so little about itself. In the hands of ruling society, the institution
of the illustrated magazines is one of the most powerful weapons
in the struggle against knowledge. A bright arrangement of images
is not the smallest factor in the successful waging of this struggle.
The *juxtaposition* of images systematically excludes the perspective
that is being opened to consciousness. The "picture-idea" expels the
idea, and the blizzard of photographs betrays their indifference to
what things mean. It does not have to be like this. But the American

illustrated magazines, which those of other countries try to emulate, equate in any case the world with the model of photographs. This equation is not made without grounds. For the world has given itself a "photograph-able face"; it can be photographed because it strives to dissolve itself within the spatial continuum that yields to snapshots. It sometimes depends on the split second that is enough to put lighting on a subject, as to whether a sportsman becomes so famous that photographers then illuminate him on assignment from the illustrated magazines. The figures of the pretty girls and of the young men are to be captured also by the camera. That the camera gobbles the world is a sign of the *fear of death*. Image photographs would like to banish with their proliferation the remembrance of death that comes with every memory. In the illustrated magazines, the world has become a photograph-able present and the photographed present is made totally eternal. This present seems to have been snatched from death but in reality it is delivered up to it.

7

The series of visual representations, whose last historical step is photography, begins with the *symbol*. It goes back to the "natural community" in which man's consciousness is still immersed in nature. "The history of words always begins with the sensuous, natural signification, and only in the course of development arrives at abstract, figurative meanings; and in religion, in the development of the human individual and of mankind, the same progress from the material to the psychic and spiritual can be noted. Likewise the symbols in which the earliest mankind set forth its institutions of nature and the environing world began with purely physical and material meanings. Symbolism, like language, is taught by nature."* The quotation

* Johann Jacob Bachofen, *Oknos der Seilflechter, ein Grabbild* (Munich, C. H. Beck, 1923) p. 22, trans. "Ocnus the rope Plaiter", *Myth, Religion, and Mother Right*;

comes from *Bachofen's*[14] essay on rope-weaving Oknos, in which it is shown that the spinning and weaving represented in the image originally were a reference to the activity of the formative power of nature. To the degree that consciousness becomes aware of itself and that the initial "identity of nature and man" (Marx, *The German Ideology*)[15] dwindles the image takes on an ever more abstract, immaterial meaning. But whether or not this meaning advances to the designation of, as Bachofen puts it, "the mental and spiritual",* the meaning is so immersed in the image that it cannot be separated from it. For long stretches of subsequent history, pictorial representations remain symbols. As long as man needs symbols, he finds himself in a practical dependence on the realities of nature which determines the visible and bodily dimensions of consciousness. It is only with the increasing mastery of nature that the image loses its symbolic power. Consciousness, separating itself from, and opposing itself to, nature, is no longer a chrysalis encased in its mythological sheath: it thinks in concepts which, however, may be used with thoroughly mythological intent. The image is still not without power in certain epochs; symbolic representation becomes *allegory*. "The latter means simply a general concept or an idea that is different to itself, while the symbol is the sensory, embodied idea itself".** This is how the old Creuzer[16] defines the difference between the two types of image. At the stage of symbol, what is thought is contained in the image; at the stage of allegory, the thought preserves and uses the image as if consciousness hesitated to throw off its shell. This schematic account is crude. It is sufficient if it demonstrates the change of representations that is the sign of the departure of consciousness from its immersion in nature. The more decisively consciousness frees itself from nature in the course of the historical process, the more

selected writings of J.J. Bachofen, trans. Ralph Mannheim, Princeton, New Jersey: Princeton University Press 1967), p. 54–55.

* Ibid. p.54.

** Georg Friedrich Creuzer *Symbolik und Mythologie der alten Völker, besonders der Griechen*, (Leipzig & Darmstadt: K.W. Leske), 1810, vol. 1, p. 83.

purely do its natural foundations present themselves to consciousness. For meaning no longer appears to consciousness in images but instead the process of meaning is directed at, and penetrates, nature. European painting of recent centuries has to an ever greater extent represented nature stripped of its symbolic and allegorical meanings. As a result, the human features depicted in this new painting are certainly not without meaning. In the time of the old daguerreotypes, consciousness was still so bound up with nature that the faces make realities present that cannot be disconnected from the natural life. Since nature changes in exact accord with the prevalent state of consciousness, the natural foundations that are devoid of meaning come to the fore with modern photography. Photography is subordinate, no less than are other earlier types of representation, to a particular stage of development of practical and material life. This stage has generated out of itself the capitalist process of production. The same bare nature, which makes its appearance in photography, lives in the reality of the society created by the capitalist process. This allows one to imagine a society that has completely given in to mute nature, a society that means nothing, however abstract its silence may be. Its outlines emerge in the illustrated newspapers. Were this society to last, the consequence of the emancipation of consciousness would be the destruction of consciousness; nature, not being grasped by consciousness, would take the place left by the latter at the table. If this society is not lasting, an incomparable opportunity is given to the freed consciousness. Less mixed than ever with stocks of nature, consciousness can prove its might over them. The turn to photography is history *betting against the house.*

8

Although the grandmother has disappeared, the crinoline has remained. The totality of photography is to be thought of as nature's *general inventory* where nature cannot be reduced any further. It is to be thought of as the comprehensive catalogue of all appear-

ances that arise in space, in so far as these are not constructed from the monogram of objects or persons, but show themselves from a natural perspective that the monogram does not render. To the spatial inventory, there corresponds the temporal one of historicism. Instead of preserving the "history" that consciousness reads from the temporal sequence of events, historicism makes a register of the temporal sequence of events, whose connections are not contained in the transparency of history. The bald declarations of space- and time-inventories belong to a social order that regulates itself by economic laws of nature.

Consciousness immersed in nature is not able to see its own foundation. It is the task of photography to show what has until now not been seen: the *natural foundation*. For the first time in history, photography exposes the whole natural husk, for the first time, through photography, the world of the dead presents itself in its independence of man. Photography shows towns from an aerial perspective, it brings down the gargoyles and figures from the Gothic cathedrals. All spatial configurations are incorporated in the main archive in unusual intersections that distance them from human proximity. When the grandmother's attire has lost its relation to today, it will no longer be funny but remarkable, like an underwater polyp. The demonic will one day vanish from the film star, and but the tomboy hairstyle will remain, as do the chignons. In this way, the inventory crumbles, for nothing holds it together. The photographic archive collects in copies the last elements of nature that have been alienated from what was meant.

This storing up of nature furthers the dispute between consciousness and nature. Just as consciousness finds itself facing the fully uncovered mechanics of industrialised society, so too, thanks to photographic technology, it faces the reflection of the reality which has slipped away from it. To have provoked in every area the decisive dispute: this is exactly the bet against the house of the historical process. The pictures of the stock of nature dissolved into its elements are handed to consciousness to do with what it wishes. Their basic order is gone, and they no longer cling to the spatial

coherence that linked them with an original, from which the memory image had been derived. But if the natural remains do not aim at the memory image, then their visually conveyed order is necessarily provisional. It would then be incumbent on consciousness to demonstrate that all given configurations are *provisional*, if not to awaken a presentiment of the correct order of the stock of nature. In Franz Kafka's works, the freed consciousness rids itself of this duty; it shatters natural reality to pieces and shifts the fragments around. The disorder of the remains mirrored in photography can be most clearly set out by the cancellation of all the usual relations between the elements of nature. To not leave these relations be is one of the possibilities of film. This possibility is realised by film whenever it associates parts and clips together in strange configurations. While the helter-skelter of the illustrated magazines is pure confusion, this game with nature cut into pieces is reminiscent of *dream* in which the fragments of everyday life get jumbled up. The game indicates that the valid organisation of things is not known in the light of which the remains of the grandmother and of the film star will one day have to find their place within the general inventory that has absorbed them.

Frankfurter Zeitung, 28th October 1927

An der Grenze des Gestern.

Zur Berliner Film- und Photo-Schau.

Von S. Kracauer.

Berlin, im Juli.

In einem Ladenkomplex der Joachimsthaler Straße ist jetzt eine **permanente Film- und Photo-Schau** eröffnet worden, die ein Material vereint, wie es in dieser Fülle noch niemals geboten wurde. Dokumente, Bilder und Proben sind hier zusammengestellt, die von den ersten Anfängen der Photographie und des Films bis zur jüngsten Gegenwart reichen. Sie gewähren einen nahezu lückenlosen Ueberblick über eine Entwicklung, an der wir selber so ganz beteiligt waren, daß wir sie bisher nicht von uns abzulösen vermochten. Durch diese Sammlung erst wird das ungewußt mitgeführte Leben offenbar und tritt uns fremd gegenüber. Und indem wir sie mustern, erkennen wir, nicht ohne zu schaudern, wie das Heute stückweise in die Vergangenheit zurücksinkt und das Vergangene stetig im Heute weiter rumort.

*

Die Ausstellungsräume erinnern an Buden. Alle Wände sind von oben bis unten mit Photos gepflastert, und dazwischen leuchten immer wieder grelle Außenplakate. Noch andere Umstände tragen dazu bei, den Eindruck des Jahrmarktzaubers zu wecken. Der Betrieb dauert bis in die späte Nacht; in einem der Räume, der als altes Vorstadt-Kintopp ausgestattet ist, werden verschollene und neue Filme gezeigt; die Schaufensterdekoration gleicht einer sichtbar gewordenen Drehorgelmelodie; der Eintrittspreis ist so niedrig gehalten, daß die offene Ladentür nicht als unüberwindliches Hindernis wirkt. Kurzum, die Straße zieht sich tief in die Schau hinein, und deren heimlichte Winkel noch sind für Passanten geschaffen. Mag die Improvisation, die hier herrscht, den Absichten der Veranstalter oder einfach der Knappheit an Mitteln zu danken sein: sie entspricht jedenfalls genau dem Gegenstand, der vorgeführt werden soll. Diese Bilder müßten nicht allein ihrer Herkunft und ihres Sinnes wegen in hellen, vornehmen Museumssälen ersticken, sondern wären auch darum in einer solchen Umgebung schlecht untergebracht, weil sie noch nicht völlig historisch geworden sind. Ihr Ort ist an der Grenze zum Gestern, an der nur improvisiert werden kann. Denn im Zwielicht dort verschwimmen vorerst die Konturen, und das Rauschen des gelebten Daseins klingt in die kaum verlassenen Felder herüber.

*

Aus der Urzeit stammt die Aufnahme eines Fensters von Niépce, der zwischen 1816 und 1830 gewirkt hat und der Vorläufer Daguerres gewesen ist. Die Photographie ist auf besonders präpariertem, in Asphalt getränktem Papier hergestellt worden und wird keine lange Lebensdauer mehr haben. Schon zeigt das Bild Sprünge und Risse, schon droht die Gestalt wieder in die Monotonie des Grundes einzugehen, dem ihr Schöpfer sie abgelistet hatte. Es muß für ihn ein Glück ohnegleichen gewesen sein, alle

todgeweihten Dinge zu bannen. Noch ist die Erscheinung deutlich zu sehen, mit dem Fensterkreuz und der steinernen Brüstung — ein armseliges Fenster an irgendeinem Pariser Haus. Aber gerade die Nichtigkeit dieses Sujets veranschaulicht das von den ersten Lichtbildnern beseelte Gemeinte. Sie waren zweifellos von der Mission erfüllt, das Zeitliche einer Welt zu segnen, die das Zeitliche segnet. Und die Rührung, die sich der heutigen Betrachter beim Anblick des vergilbten Blattes bemächtigt, erklärt sich eben daraus, daß es zum Unterschied von den meisten modernen Photos das Vergängliche retten, nicht aber bis zum Ueberdruß vereinigen will. Dadurch, daß es ein flüchtiges Phänomen um seines möglichen Sinnes willen wunderbar zum Stehen bringt, ruft es wieder die ursprüngliche Bestimmung der photographischen Technik ins Gedächtnis zurück, deren Rutznießer sich längst damit begnügen, die Verflüchtigung unwesentlicher Phänomene sinnlos aufzuhalten.

*

Anfänge des Films: eine Wundertrommel wird gedreht, und aus kleinen Bilderheftchen, die man wie ein Kartenspiel rasch mit dem Finger überschlagen kann, erstehen kunstlose Szenen. „Du ahnst es nicht", heißt eines der Heftchen, und diese Behauptung ist dazu geeignet, die Neugier von Rummelplatz-Besuchern zu wecken. Noch erhalten sich im Luna-Park die Biofixbilder-Apparate jener toten Zeiten fort, die der spendierfreudigen Lüsternheit übertriebene Versprechungen machen. Schaubudenluft umweht überhaupt den Beginn der ganzen Filmproduktion, ist die Atmosphäre, in der gemächlich das Instrumentarium, dessen sich dieser Erfinder bedient, schon viele, später herausgearbeitete Möglichkeiten in sich enthält, so ist die Stelle, an der ins jungfräuliche Stoffgebiet eingebrochen wird, für die Zukunft entscheidend. Immer haben die Umstände, unter denen eine neue Entwicklung anhebt, einen unabsehbaren Einfluß auf deren Verlauf. Den Versuche Max Skladanowskys gediehen. Und wie das ungeschlachte Instrumentarium, dessen sich dieser Erfinder bedient, schon viele, später herausgearbeitete Möglichkeiten in sich enthält, so ist die Stelle, an der ins jungfräuliche Stoffgebiet eingebrochen wird, für die Zukunft entscheidend. Immer haben die Umstände, unter denen eine neue Entwicklung anhebt, einen unabsehbaren Einfluß auf deren Verlauf. Den Skladanowsky geschaffene erste Spielfilm der Welt nennt sich: „Die Rache der Frau Schultze" und ist eine Art von Moritat, deren Bilder von Versen wie diesen begleitet werden:

> „Abends, wenn die Glocke zehn,
> Will Frau Schultze schlafen gehn,
> Ihr Herr Nachbar — componiert,
> Spielt Posaune und klaviert."

Bezeichnend auch, daß eine Zirkusreiterin die Rolle der Rächerin spielt. Alle Filme von damals sind Illustrationen zu Bänkelsängerweisen oder vergegenwärtigen wie selbstverständlich kolportageähnliche Themen. Derselbe Zwang, dem die Techniker bei der Ausbildung der Apparatur gehorchen, führt sie Motiven zu, die unterhalb der offiziellen Literatur ihr Wesen treiben. Es ist die Welt der Volksbelustigungen, in die sie vorstoßen, der primitiv gemalten und genossenen Abenteurergeschichten, der Zehnpfennig-Broschüren, die in Schreibwarengeschäften und Hinterhöfen an die halbe Oeffentlichkeit kommen. Wenn aber diese Welt als erste dem Film erobert wird, so heißt das nichts anderes, als daß er ihr zugeordnet ist. Und in der Tat: als ein Geschöpf der Straße,

On Yesterday's Border
On the Berlin Film and Photo Exhibition

A *permanent film and photo exhibition*[1] has been opened in a com-
plex of shops in Joachimsthaler Street. It brings together material
that has never been shown before in such a comprehensive way.
Documents, pictures and test samples are brought together here,
reaching from the very beginnings of photography and film to the
immediate present. They provide an almost seamless overview of
a development in which we have so fully participated that we have
up to now been unable to tell it apart from ourselves. Only with
this collection does the unconscious life that we have been carrying
in ourselves become open and stand there facing us as something
strange. And in scrutinising the collection, we recognise, not with-
out a shudder, how the present in parts sinks back into the past and
how the past constantly haunts the present.

*

The exhibition rooms are reminiscent of market stalls. All the walls
are plastered from top to bottom with photos, and in the gaps
between them gaudy street posters stand out now and again. Fur-
ther factors contribute to awakening the impression of fairground
magic. Business goes on late into the night; in one of the rooms that
is fitted out as one of the old suburban cinemas, forgotten and new
films are shown; the shop window decoration is like a barrel organ
melody made visible; the entry price has been kept so low that the

47

open shop door does not have the effect of being an insurmountable barrier. In short, the street draws itself right into the show and its most hidden corners are still made for passers-by. Whether the improvisation that rules here is down to the intentions of the organizer or is simply thanks to the lack of means, it is in any case in perfect keeping with the subject that is to be presented. These pictures would suffocate in the bright, grand rooms of a museum not only because of their origin and their meaning but they would also be out of place in such surroundings because they have not yet become fully historical. Their place is on yesterday's border where things can only be improvised. For in the dim light, contours are blurred for now and the murmur of lived experience echoes across into the newly deserted fields.

*

The photograph of a "Window" by *Niépce*[2] comes from the very beginnings. He was active between 1816 and 1830 and was a forerunner of Daguerre. The photograph was produced on specially prepared paper soaked in bitumen, and will not survive much longer. The picture is already showing cracks and tears, the form already threatens to dissolve again into the monotony of the background from which its creator had conjured it. For him it must have been a cause of incomparable joy to be able to capture all passing things. The subject is still clearly visible, with its mullion and transom and stone balustrade – a paltry window in any Parisian house. But it is precisely the triviality of the subject that makes visible the meaning of the first photographs. They were doubtless driven by the mission to sanctify the time-bound quality of a world that was dying. The emotion that overpowers the contemporary viewer looking at the yellowed sheet is to be understood from the fact that, in contrast to most modern photos, the desire is to save the transient and not to make it eternal to excess. The way that the photograph brings wonderfully to a standstill a fleeting phenomenon for the sake of the latter's possible meaning, calls to mind the original vocation of pho-

tographic technology, where its users were for a long time content to pointlessly arrest the disappearance of inessential phenomena.

*

The beginnings of film: a magic cylinder is rotated[3] and ordinary scenes are generated out of small picture-books by rapidly flicking through them as if each were a pack of cards. "You Cannot Have Any Idea", is the title of one of these little books and the claim is aimed at awakening the curiosity of fairground visitors. The Biofix machines[4] of that period are still in use in Luna Park, making exaggerated promises to spendthrift lechers. An atmosphere of fairground show booths generally wafts around the beginnings of all of film production. It is the atmosphere in which the experiments of Max Skladanowsky thrive.[5] Just as the rough-and-ready range of instruments used by this inventor already contains within it many possibilities that came to be worked out later, so too, the place at which this virgin area is broken into, is decisive for the future. The circumstances within which a new development emerges, always have an unforeseeable influence on its course. The first ever feature film, that was made by *Skladanowsky*, is called *Die Rache der Frau Schulze*[6] and is a sort of street ballad whose images are accompanied by verses like these:

> In the evening, when the clock strikes ten,
> Mrs. Schultze wants to sleep in her den,
> Her dear neighbour – is composing,
> Tinkling the piano and tromboning.

It is telling that a woman circus rider plays the role of the avenger. All films of that time are illustrations of balladeers' songs or they present as real sensationalist-type themes. The same forces that the engineers obey in developing the apparatus also bring themes to the films which live their life below official literature. They venture into the world of fairground spectacles, of primitively made – and primitively revelled in – adventure stories, of the ten penny dreadfuls

found in the half-public areas in stationers' shops and in backyards. But if this world is the first to be claimed for film, this means nothing other than that film fits in there. And indeed, film later enjoys its greatest triumphs as a creature of the street, as a conveyor of those indestructible, great themes that are presented more clearly in the show tent than they are in so-called literature and that give happiness to those unsullied by education and to the wise. The Chaplin routines that carry the indelible mark of film's origins on their brow, are also the highpoint of film.

*

Rache der Gefallenen. Sittengemälde in vier Akten[7] a tired film carries this title, with the young Hans Albers featuring as the demonic seducer.[8] His locks still wave in their full splendour, and his vanity still has the innocence of the heroes in novels read by servant girls. He now wants to be the folk figure that he perhaps really was in his early days, but he does not carry it off any more. The kitsch that he once played was of a popular nature that had meaning, while the nature that he now mimes in the interest of his popularity, is kitsch. A still photograph from the film is revealing. The (apparently already fallen) heroine is standing with a pistol in her hand in a richly appointed family drawing-room opposite an easel painting of the seducer in a tailcoat, and she harbours feelings that the text expresses as follows: "I once loved this man. Oh, how I hate him now! I must kill him, if it only be in a painting." Instead of us noticing the agitation of the heroine that these words betray she, on the contrary, gives the impression of someone who is completely uninvolved. With the calm bearing of an elevated middle-class statue, she fills the middle of the room, and the calm which prevents her bosom from heaving fully corresponds to the indifference with which she holds the revolver. The murder instrument might as well be an empty match box that in the next moment is put down, so slight are its relations to the fallen woman and to the tails. But why these tragic words? The still on display shows that at the time it was

made, the space that has since been won by film had not yet been opened up. The drawing-room is an adapted theatre set, the actors are theatre actors who are not supposed to speak, the furniture comes from the props room, and the camera is afraid to budge. As long as this proto-stage lasts, the people and things belong neither to the theatre, in which they can make themselves understood, nor yet to the world that can be mirrored on the screen. They are ghosts moving about *in the mists of dawn*, whose speech is not ours. Their gestures seem to write off their words as lies, their motionlessness is turmoil, and their pistols shoot into the void. When the camera wakes from its paralysis, they will give way.

*

Many films of past periods are only *funny* now. This is not where they want to be funny, but comes precisely at the culminating points of their seriousness. In the middle of a cemetery set, for example, which clearly forms the moving conclusion to a dramatic piece of action, linger a well-dressed man – who would do honour to any Courths-Mahler[9] novel – and the kneeling Henny Porten.[10] The commentary to the text in images runs:

> "The most beautiful spot that on earth I have
> Is the grassy bank by my parents' grave."[11]

There is not the slightest doubt that the mourning figure and the man standing somewhat to one side are badly shaken. Despite this, the image provokes laughter, and there are other, less crass scenes from outmoded society films that have also been consigned irretrievably to the comic register. This comes from a particular change that has happened with these images. Where they revealed to their first viewers essentially the content that was intended by them, they reveal to contemporary viewers the strange, just decayed milieu in which this content announced itself so naïvely, as if it were really rooted in that milieu. We see not only the man's emotion but also his

antiquated jacket and we are obliged to notice that Henny Porten's mourning is taking place under the old-fashioned shape of her hat. The emphasis of the images has shifted, and the fashionable, external elements that had gone unnoticed originally have come to the fore like a secret alphabet. Instead of being moved by the pathos that exuded from the heroes in the period when they were contemporary, what alone strikes us about them now is the derisory contrast between their emotional claims and their obsolete appearance. Since film presents life as it appears more fully than any other art form, perhaps one of its tasks is to make us always aware of the questionable intertwining of fleeting time with feelings and passions which claim to last. The amusement aroused by film strips that have very recently become outdated has a sombre foundation indeed, for the sight of clothes and gestures with which we had very recently expressed ourselves, reminds us of the decline of any present whatsoever. And doubtless many sports events, tragedies etc. that we come across on the screen today, will soon have as comic an impact as the pair at the parents' grave. Only a reality that has become fully historically conscious could be free of this comic effect, a reality that no longer stretches over into our own, and contents that are so very evident and overpowering that they even conquer their transient appearance. But where could they be found in the contemporary world?

*

The exhibition moves imperceptibly from the past to the present. A few stages in the development can, however, be made out. The letter of Max Mack to Albert Bassermann is exhibited in which the latter, who had until then resisted being filmed, is successfully implored to take a role in the film *His Own Murderer*.[12] On show are images of the first set built in a studio. There are samples of films that introduced a new series or that at the technical level introduced a new stimulus. But despite these small signals, one does not find a threshold behind which would lie the past for once and for all, rather than glide, as it does, without intermediate steps into the

present. The uncanny feeling that comes from not really knowing when modern dress supersedes the old, is further heightened by the awareness that through the technical progress the emptiness of films themselves grows. At the end of the exhibition, a new sound film camera has been assembled; its relation to Skladanowsky's ungainly bioscope being akin to that of an elegant modern car to an early Ford. The films, however, that emerge from this sleek, wonderfully engineered apparatus, do not fulfil the expectations that could be attached to this bringing to perfection of the original model. On the contrary, the more the films become industrial products, the more hollow they sound, and the increase in the technical know-how invested in them seems to actually entail a *lessening of their substance*. They turn correct intentions on their head, they increase sensationalism and by so doing lower its level, they pass on rotten ideologies to the public and they obstruct their contents with the sets. It did not have to have been like this but this is how it has come to be. Moving through the exhibitions is exactly like sliding into an abyss. But one hope remains: the masterful apparatus that produces these trivial products. It cannot have been created in vain but must one day fulfil a function that really suits it.

*

It is worth adding that the enormous amount of material that will be made accessible to the public, step by step, was provided by countless people involved in making films. Directors opened their private archives, and extras supplied valuable old photos. The company organising the exhibition is contributing set percentages of the exhibition's gross revenues to the social insurance funds of some film associations. The company also wants to found subsidiary exhibitions in other big cities of the country. Lectures of the most varied kinds and special events from specialised areas are planned in the main space itself.

Frankfurter Zeitung, 12th July 1932

Photographiertes Berlin.

Berlin, Mitte Dezember.

Im Lichthof des Kunstgewerbemuseums werden 1000 Berliner Ansichten gezeigt, die von A. Vennemann photographiert worden sind. Sie kleben auf braven weißen Kartons und veranschaulichen alle möglichen Einzelheiten des Berliner Lebens, das der Oeffentlichkeit zugewandt ist. Daß sie ein wenig starr wirken, so, als seien sie stehen geblieben, erklärt sich zweifellos aus der durch den Film veränderten Art unseres Sehens. Der Film hat uns daran gewöhnt, die Gegenstände nicht mehr von einem festen Standort aus zu betrachten, sondern sie zu umgleiten und unsere Perspektiven frei zu wählen. Was er vermag: Die Fixierung von Dingen in der Bewegung, ist der Photographie versagt. Daher erscheint sie dort, wo sie noch Selbständigkeit beansprucht, als eine Form, die historisch zu werden beginnt. Sie läßt sich langsam aus der Gegenwart und nimmt schon ein altmodisches Wesen an. Hierin gleicht sie der Eisenbahn, die sich zum Flugzeug wie die Photographie zum Filmstreifen verhält. Eisenbahn und Photographie: beide sind Zeitgenossen und einander darin verwandt, daß sich ihre Gestalten vollendet haben und längst die Vorläufe neuer Gestalten bilden. Wir haben uns heute von den Schienen nicht anders abgelöst wie von der einst für die Kamera unerläßlichen Ruhelage. Und gehört auch die Photographie noch durchaus dem Heute an, so fallen doch bereits jene Schatten auf sie, die alle fertigen Besitztümer umhüllen.

*

Aufgenommen sind fast lauter Objekte, die man vom Alltag her kennt. Altberliner Häuser, Schlösser und Paläste, Straßen und noch einmal Straßen, spielende Kinder, Restaurants, Werktätige der verschiedensten Berufe, Passanten, Weekend-Ausflügler, Parkanlagen und schöne Punkte der Umgebung, Bahnhöfe, Industriewerke und moderne Geschäftsbauten — das Inventar könnte schwerlich vollständiger sein. Diese vielen Bilder sprechen vor allem zur Erinnerung. Sie beschwören Eindrücke herauf, die wir gehabt haben, ohne uns Rechenschaft über sie abzulegen, sie bannen Altvertrautes, das die ganze Zeit über mit uns gegangen ist. Die Lichtreklamen sind unsere Abendgesellschaft, und ebenso ist uns schon manchmal der spielende Gassenjunge erschienen, der die Ritzen zwischen den Pflastersteinen austrägt. Sämtliche Photographien rufen eigentlich nur die optischen Bestände ins Gedächtnis zurück, die unserem Dasein einverleibt sind. Nichts aber ist mehr in Ordnung, als daß sich gerade jene Welt vergegenwärtigen, die wir besitzen. Denn sie und nicht die neue, zu erobernde Welt ist der rechtmäßige Gegenstand der Photographie. Tatsächlich vermag ein photographisches Bild keinen vollen Begriff von irgendeinem Ding zu verschaffen, das der Betrachter des Bildes noch nicht gesehen hat. Das Original einer Aufnahme läßt sich aus dieser niemals erschließen, und die zahllosen photographischen Reproduktionen von Kunstwerken verbreiten nicht etwa die Kenntnis der Werke, sondern

beweisen nur, daß die reproduzierte Kunst ihre eingreifende Wirkung verloren hat. Eine unzulängliche Ansichtspostkarte, die man von einer Reise mitbringt, erfüllt die dem Lichtbild zukommende Funktion besser als eine Prachtphotographie unbereister Gegenden. Es wäre nützlich, einmal genauer zu untersuchen, bis zu welchem Grade die in den Illustrierten angeschwemmten Aufnahmen die Aufnahmefähigkeit des Publikums für die sichtbare Welt ersticken. Die Photographie gibt ja nicht die Bedeutungen mit, die erfahren sein müssen, um ein Objekt zu unserem Objekt zu machen — sie spiegelt nur das aus allen Erfahrungszusammenhängen gerissene Objekt wider. Nicht das Aeußere des Objekts, sondern eine unverbindliche Abstraktion von ihm geht ins photographische Bild ein. Statt also einen Gegenstand vorzustellen, ist die Photographie auf den bereits vorgestellten Gegenstand angewiesen, um ihn überhaupt darbieten zu können. Ihr Hauptfeld ist das versunkene Bekannte. In der Ausstellung dient sie auch wirklich als Führer durch die Erinnerung. Indem sie uns aber zu einer erstaunlichen Fülle von Wiederbegegnungen verhilft, erteilt sie uns endlich die Verfügungsgewalt über die Sachen und Figuren, mit denen wir unbewußt lebten.

Besonders gelungen sind einige Bilder aus dem Tiergarten. Sie bringen das Teichhafte, Verschollene des Tiergartens dadurch heraus, daß sie kaum höher als bis zum Ansatz des Laubes bringen und den Himmel ganz unterschlagen. So wird die freie Natur draußen ferngehalten und der Binnencharakter des künstlichen Parks betont. Abgeschnürt von der Gegenwart, scheint er schon ins Vergangene eingerückt zu sein. Er wirkt wie ein Gleichnis der Photographie selber, und vielleicht folgt ihm diese darum so mühelos nach, weil auch sie an der Schwelle des Gestern weilt.

S. Kracauer.

Bach, Haydn, Mahler.

Im Zeichen dieser drei Meisternamen stand das fünfte Montagskonzert des Frankfurter Orchestervereins. Zu Anfang die Kantate „Ich bin vergnügt mit meinem Glücke", Solo-Kantate für Sopran, mit vierstimmigem Schlußchoral, von Bach: Solo-Kantate für Sopran, mit vierstimmigem Schlußchoral, von Bach. Sie gab Ria Ginster Gelegenheit, ihre ansprechende Stimme und ihre weitaus bedeutenderen Sing-Kunst glänzen zu lassen im konzertanten Zusammenspiel mit dem Orchester, in dem die Herren Amar (Violine), Furmann (Oboe) und E. J. Kahn (Cembalo) hervortraten. Die Kantate selbst gibt nicht allzu viel her; mehr eigentlich in den Rezitativen als in den zwei Sopranarien. Man denkt in Abbertmeßt gerade dieser Solistin in der weihnachtlichen Zeit unwillkürlich an andere, ergiebigere Kantaten wie z. B. „Süßer Trost, mein Jesus kommt", die freilich ein Solo-Quartett erfordert.

Eine angenehme, für die meisten Hörer wohl überraschend beglückende Begegnung war auch die mit der „Sinfonie concertante" in B-dur von Haydn. Ein Prachtstück der Musizierfreude und des Wohllauts im Wettstreit des Solo-Concertinos: Violine (Amar), Violoncell (Frank), Oboe (Furmann), Fagott (Jung) mit dem großen, größeren Orchester. Wir haben das Werk von den Wiener Philharmonikern im Sommer in Eisenstadt gehört, in einem Gasthaus-Saal unweit des Schlosses, in dem Haydn selbst musiziert hat. Um wieviel blühender erklangen seine Sinfonien in Räumen von dem Ausmaß, für das sie ursprünglich geschrieben sind. (Die Frankfurter

Photographed Berlin

In the glass-covered atrium of the Arts and Crafts Museum "1,000 Views of Berlin" is on show: photographs by *A. Vennemann*.[1] They have been stuck on simple white cardboard and illustrate all possible details of Berlin life that are oriented towards public space. The views come across as a bit stiff, as if everything were standing still, but this is to be explained, no doubt, by the change in our way of seeing that cinema has brought about. Film has made us used to no longer considering a thing from a fixed viewpoint but, rather, to glide around it, choosing our perspectives as we want. What film is able to do – to record things in motion – is denied to photography. Hence, where photography wants to make a claim for its independence, it appears to be a form that is beginning to become historical. It is detaching itself slowly from the present and has already acquired an old-fashioned nature. It is similar to the *railway* in this; the railway is to the airplane what photography is to the film reel. The railway and the photograph are contemporaneous with each other, are similar for having both perfected their forms, and they have long since become forerunners in the creation of new forms. We have separated ourselves nowadays from the rails in the same way that we have from the once mandatory stillness of the camera. So if photography also belongs utterly to the present, already those shadows fall on it that surround all completed achievements.

*

Subjects known from everyday life are virtually the only ones that are reproduced here. Old Berlin houses, castles and palaces, streets and more streets, children playing, restaurants, people from all sorts of professions, passers-by, people on weekend outings, public parks and pretty spots in the surroundings, railway stations, industrial plants and modern office buildings – the inventory could scarcely be more complete. These many pictures speak above all to our memory. They conjure up impressions we have had, to which we have paid no heed. They summon up old familiar things that have been with us all this time. The illuminated advertisements are our evening company, and the young, playing street-boy has likewise appeared to us a few times, scratching out the gaps between the cobblestones. All the photographs recall from memory only *those* optical elements that live within our existence. But nothing is more apt than that photographs would make present precisely the very world that we possess. This world, not the new, yet to be conquered, world, is the rightful subject of photography. It is a matter of fact that a photographic image cannot give a complete idea of anything whatsoever if the person viewing the image has not already seen the thing. What was originally photographed can never be deduced from the photograph, and the countless photographic reproductions of works of art do not disseminate knowledge of the works as sup-posed but only go to prove that art reproduced has lost its marking impact. A weak picture postcard that one brings back from a journey better fulfils the function of a photograph than does an elaborate, showy photograph of unvisited destinations. It would be useful to study more closely at some point to what extent the gluts of shots in the glossy magazines stifle the public's receptive capacity for the visible world. Photography does not convey the meanings that must be experienced for a thing to become ours – it only gives a mirror reflection of the thing torn out of all relations to experience. It is not the external appearance of the thing but rather an abstraction without coherence that passes from the thing into the photographic image taken of it. So instead of presenting a subject, photography relies on the concept we already have of the thing, so as to be able to

present it. Photography's main field is what is known and familiar, but goes unnoticed. Photography indeed serves in the exhibition as a *guide through memory*. As it helps us to an astonishing plenitude of re-encounters, it finally shares with us the power to access things and figures with which we have unconsciously lived.

*

Some images from the *Tiergarten* are particularly successful. They bring out the pond-like, forgotten element of the Tiergarten by stretching to no further than the base of the shrubs and by suppressing the sky completely. Thus free nature is held at bay, outside, and the interior character of the artificial park is accentuated. Detached from the present, the garden seems to be already enmeshed in the past. The park could be a symbol of photography itself, and perhaps the latter follows the park so effortlessly because photography also whiles away its time on yesterday's threshold.

Frankfurter Zeitung, 15th December 1932

Anmerkung über Porträt-Photographie.

Berlin, Ende Januar.

Eine in Berlin gezeigte Ausstellung guter **Bildnis-photos** bietet die Gelegenheit zu einer grundsätzlichen Betrachtung über die Chancen photographischer Porträtkunst. Warum sind sehr viele Bildnisse, und gerade die sogenannt künstlerischen, so verlehrt? Ich denke an Porträts, wie man sie häufig hinter Glas und Rahmen an den Eingängen photographischer Ateliers hängen sieht. Irgend ein renommierter Männerkopf taucht aus mystischem Dunkel auf, oder eine beliebte Schauspielerin muß sich dämonisch gebärden. Gibt eine der normalen Ansichten noch den Begriffen der Beteiligten nicht genug her, so werden ungewohnte verwirqt. Das Gesicht erscheint in kühnen Perspektiven, die etwas Bedeutendes ausdrücken sollen, die Kinn- oder Stirnpartien erhalten ein Uebergewicht, das sie im Alltagsgebrauch vermutlich gar nicht besitzen, und Brillenreflexe werden zum optischen Hauptelement. In allen diesen Fällen handelt es sich immer um das gleiche Gebrechen. Es besteht darin, daß die Photographie nicht die zu porträtierende Physiognomie vergegenwärtigt, sondern sie als Mittel zu Zwecken benutzt, die außerhalb des Objekts liegen. Welche photographischen Möglichkeiten enthält der Kopf? Das ist die Frage, die in solchen Bildnissen aufgeworfen und beantwortet wird. Mit anderen Worten: sie erstreben von vornherein weniger die Wiedergabe ihres Gegenstandes als die Vorführung sämtlicher Effekte, die aus ihm etwa herausgelockt werden können. Entscheidend sind natürlich jene, die dem Handwerk entsprechen: also Licht- und Schattenwirkungen besonderer Art. Wehe dem Typ, der zu ihrer Ausgestaltung anzuregen vermag. Ohne Rücksicht auf die mit ihm vielleicht gesetzten Gehalte wird er bestrahlt oder verfinstert, und was dann von ihm übrig bleibt, ist eine Schwarz-Weiß-Komposition. Sie beschränkt sich oft genug nicht auf ornamentale Reize, sucht vielmehr, schlimmer noch, eine künstlerische „Auffassung" zu dokumentieren. Tatsächlich setzen manche Bildnisphotographen ihren Ehrgeiz darin, über das Technische hinaus auch Kunstwerke zu liefern und die Physiognomie gewissermaßen zu beseelen. Statt nun aber aus dem Objekt heraus eine ihm sachlich zugeordnete Auffassung zu entwickeln, fügen sie ihm diese zu wie eine Sauce. Ob es dem Kopf recht ist oder nicht: er muß sich vor ihr übergießen lassen. Hier wäre der Ort für einen soziologischen Exkurs, der sich mit der in zahlreichen Bildnisphotographien investierten Mentalität zu beschäftigen hätte. Diese Mentalität weist zweifellos einige typische Züge auf, die nicht so sehr den Porträtierten als den Porträtkünstlern eigen. Und zwar führt deren unausgesprochene Mittelstellung zwischen reproduzierender Technik und produzierender Kunst ganz von selber zur Uebernahme gerade modischer Qualitäten. Wer nicht zur schaffenden Avantgarde gehört, muß die Neuheiten verwenden, die in der Luft liegen; bew-

ausgesetzt, daß er um jeden Preis Kunst machen will. Bestimmte seelische Haltungen drängen sich so in den Vordergrund, bestimmte Posen kehren in Bildnissen wieder, die durchaus verschiedene Gegenstände betreffen. Sie werden dem Besteller aufoktroyiert, der allerdings nicht selten Ursache hat, sich über eine solche schmückende Zutat zu freuen.

Die in der erwähnten Ausstellung befindlichen Bildnisse unterscheiden sich von den eben gekennzeichneten dadurch, daß sie ohne „Auffassung" sind. Welch ein Vorzug! Während nach dem üblichen pseudokünstlerischen Verfahren die Physiognomie zu einem Lichterspiel wird oder gar hinter etlichen von ihr unabhängigen Meinungen und Vorstellungen verschwindet, ist sie hier echter Selbstzweck. Der Photograph hat sich ersichtlich darum bemüht, ihre Eigentümlichkeiten zu studieren und ihnen dann bildmäßige Geltung zu verschaffen. Er dankt zu Gunsten des Gegenstands ab, den er möglichst charakteristisch zu vermitteln sucht. Ein deutlicher Beweis hierfür ist der Wegfall des Dekorativen, das in der Regel sonst eine Hauptrolle spielt. Gehalt und Geste stimmen in diesen Bildern wie selbstverständlich miteinander überein. Statt daß das Gesicht in eine fremde Perspektive gezwungen würde, ergibt sich diese jeweils aus seinem Wesen; statt daß ein subjektiver Stilwille sich die Alleinherrschaft anmaßte, bedingt die Essenz des Porträtierten von sich aus den Stil. Die Profile entspringen keiner Laune, die Frontalansichten sind Erfordernisse des Stoffes. Im Einklang damit verfolgen auch die Licht- und Schattenmodellierungen nicht eigensüchtige Sonderziele, sondern erfüllen die Funktion, den Text des Gesichts zu kommentieren. So verhält es sich wenigstens im Prinzip. Unstreitig sind Photographien dieser Art die einzigen, die Bildnisse heißen dürfen. Indem sie sich in die darzustellende Person hineindehnen, stoßen sie freilich auf eine Grenze, die allein der Maler zu überschreiten vermag. Er kann kraft seiner aktiven Eingriffe das Urbild, das er vor Augen hat, wirklich objektivieren; die Kamera dagegen, die nur passives Aufnahmeorgan ist, müßte sich in ihm zuletzt verlieren. Da diese theoretische Konsequenz aber ausscheidet, rückt auch die gute Bildnisphotographie, die es ernst mit dem Gegenstand meint, in eine gefährliche Nähe zum Gemälde, dem sich die schlechte vorschnell angleichen will. Sache des photographischen Taktes ist es: jene unerläßlichen Stilisierungen, die gemäldeähnliche Wirkungen zeitigen, auf ein Minimum einzuschränken. S. Kracauer.

Von den Universitäten.

Berufungen: Der Bonner Privatdozent Dr. H. Herter hat einen Ruf als a. o. Professor für klassische Philologie nach Rostock erhalten. — Der Lehrstuhl der Chirurgie an der Breslauer Universität ist Prof. Dr. K. H. Bauer in Göttingen angeboten worden. — Das Ordinariat der Geographie an der Universität Rostock ist dem a. o. Professor Dr. O. Jessen in Köln angeboten worden. — Prof. Dr. E. Zurhelle an der holländischen Reichsuniversität Groningen hat einen Ruf als a. o. Professor für Dermatologie an die Universität Rostock erhalten.

A Note on Portrait Photography

An exhibition in Berlin of good *photo-portraits* offers the opportunity for a fundamental reflection on the outlook for photographic portraiture.[1] Why are very many portraits, particularly so-called artistic ones, so odd? I am thinking of the portraits that one often sees hanging behind glass, framed, at the entrances to photography studios. Some famous man's head emerges out of a mystical darkness, or a popular actress is made to gesticulate demonically. If one of the normal viewpoints is not revealing enough, according to the conceptions of the concerned parties, the result is that some unusual things are made eternal. The face appears in bold perspectives that are supposed to express something significant, parts of the chin or of the brow are given a prominence that they do not, we can assume, possess in everyday life, and reflections from spectacles become the main optical element. What we are dealing with in all these cases is always the same shortcoming. It is that this photography, instead of visualising the physiognomy that is to be portrayed, uses the physiognomy as a means towards ends that lie beyond the subject. What photographic possibilities does the head contain? This is the question that is asked and answered in such portraits. In other words, they strive from the beginning not so much to reproduce their subject as to demonstrate all the effects that can be teased out of it. The decisive effects are, of course, those corresponding to craft touches: light and shadow effects of a particular kind. Woe betides the sitter who is able to stimulate the production of such effects.

With no attention paid to what is perhaps the person's conveyed substance, the person gets over-illuminated or obscured in shadow, and all that remains is a Composition in Black and White. The photography fairly often does not limit itself to ornamental touches but strives – this is even worse – to realize an artistic "conception". The ambition of some portrait photographers is, in fact, to go beyond technical issues, to also deliver works of art and, to an extent, to give the physiognomy soul. Instead, then, of developing a conception from their subject that is factually subordinate to that subject, these photographers inflict a conception on it as if adding sauce to it. Whether it goes with the head or not, the head must be doused with it. This would be a good point for a sociological digression on the mentality invested in countless portrait-photographs. This mentality displays certain typical features that do not so much belong to those having their portraits taken as to the photographer portraitists. And indeed photo-portraiture's unspoken intermediate position between reproductive technology and productive art makes it fertile territory for the adoption of fashionable qualities. He who does not belong to the creative avant-garde must use the new things that are in the air, assuming, that is, that he wants to make art, whatever it might take. So certain psychological stances assert themselves, certain poses recur in portraits of completely different subjects. They are pressed on the customer who certainly has reason often to be pleased by such embellishments.

The portraits featuring in the exhibition mentioned above are different to the ones just described, by having no "conception". What an advantage! Whereas according to the usual pseudo-artistic procedure, physiognomy becomes a play of light or disappears entirely beneath opinions or representations that are entirely independent of it, here the physiognomy is the true end in itself. The photographer has clearly taken pains to study the particularities of the physiognomy and then to give it pictorial validation. He makes himself subordinate to the subject that he tries to convey in the most characteristic way possible. Clear proof of this is the omission of any decorative element which otherwise plays, as a rule, a central role.

Content and gesture cohere with each other as if naturally in these pictures. Instead of the face being forced into a strange perspective, the perspective emerges in each case from the nature of the face. Instead of a subjective wish for a certain style making itself sole master, it is the essence of the person being portrayed that determines the style. The profiles do not stem from a whim and the frontal views are requirements of the material. In keeping with this, the use of lighting and shadow do not follow self-centred special aims but fulfil the function of commenting on the text of the face. That is at least how it is done in principle. Photographs of this kind are without question the only ones that should be called portraits. Given that they reach into the person being portrayed, they hit a boundary, admittedly, which only the painter is able to overcome. The painter can, thanks to his active intervention, really objectify the prototype that he has before his eyes; the camera, in contrast, being only a passive, recording instrument, would have to lose itself in the end in the prototype. But as this theoretical consequence is ruled out, good portrait photography, which takes its subject matter seriously, itself comes dangerously close to painting, to which the bad photography wants to align itself too rapidly. Integral to the photographer's tact is the reduction to the minimum of any unavoidable stylisations with painting-like effects.

Frankfurter Zeitung, 1ˢᵗ February 1933

SIEGFRIED KRACAUER

THE PHOTOGRAPHIC APPROACH

Fox Talbot, The Open Door, from The Pencil of Nature, 1844, courtesy Beaumont Newhall.

INSTANTANEOUS photography grew out of a desire older than photography itself—the wish to picture things in motion. This was a challenge to photographers and inventors. As early as the late 1850's, stereoscopic photographs appeared which evoked the illusion of capturing crowds and action. With these stereographs, instantaneous photography virtually entered the scene.

In nineteenth-century France, the arrival of photography coincided with the rise of positivist philosophy and the concurrent emphasis on science. Hence the marked concern, in the childhood days of photography, with truth to reality in a scientific sense—a concern which not only benefited the realistic trend in art and literature but facilitated the acceptance of the camera as both a recording and exploring instrument.

As a recording device, the camera was bound to fascinate minds in quest of scientific objectivity. Many held that photographs faithfully copy nature; and, eager for similar achievements, realistic and impressionist painters assumed the guise of self-effacing copyists. But it need scarcely be stressed that in actuality photographs do not copy nature but metamorphose it, by transferring three-dimensional objects to the plane and arbitrarily severing their ties with their surroundings—not to mention the fact that they usually substitute black, gray and white for the given color schemes.

In its exploration of the visible world, the camera produces images that differ from painting in two respects. Photographic records evoke not only esthetic contemplation but also an observant attitude, challenging us to discern minutiae that we tend to overlook in everyday life.

In addition, photographs permit the spectator to apprehend visual shapes in a fraction of the time he would require for a similarly acute apprehension of the actual objects. There are three reasons for this: photographs, by isolating what they present, facilitate visual perception; they transform depth to one plane; and they usually also reduce the angle of vision, thus enabling the eye to comprehend with relative ease whatever is represented.

To the nineteenth century, the unsuspected revelations of photographs were something to marvel at. Talbot, one of the founding fathers of photography, remarked as early as 1844 that, more often than not, "the operator himself discovers on examination, perhaps long afterwards, that he had depicted many things he had no notion of at the time." With the rise of instantaneous photography it became obvious that the camera is not only extremely inquisitive, but actually transcends human vision. Snapshots (in the technical sense of the word, rather than in the popular meaning of amateur photography) may isolate transitory gestures and configurations which our eye cannot possibly register. In the preface to his book, *Instantaneous Photography* (1895), the English photochemist Abney dwelt on the "grotesqueness" of the numerous snapshots which make you believe "that figures are posed in attitudes in which they are never seen."

But there is a difference between acknowledging the characteristics of a medium and actually taking advantage of them. Nineteenth-century photographers tended to submit to the visual habits and esthetic preferences of society at large. They shrank from exploring the world photographically lest the grotesqueness of their images might be

The Photographic Approach

Instantaneous photography grew out of a desire older than photography itself – the wish to picture things in motion. This was a challenge to photographers and inventors. As early as the late 1850's, stereoscopic photographs appeared which evoked the illusion of capturing crowds and action. With these stereographs, instantaneous photography virtually entered the scene.

In nineteenth-century France, the arrival of photography coincided with the rise of positivist philosophy and the concurrent emphasis on science. Hence the marked concern, in the childhood days of photography, with truth to reality in a scientific sense – a concern which not only benefited the realistic trend in art and literature but facilitated the acceptance of the camera as both a recording and exploring instrument.

As a recording device, the camera was bound to fascinate minds in quest of scientific objectivity. Many held that photographs faithfully copy nature; and, eager for similar achievements, realistic and impressionist painters assumed the guise of self-effacing copyists. But it need scarcely be stressed that in actuality photographs do not copy nature but metamorphose it, by transferring three-dimensional objects to the plane and arbitrarily severing their ties with their surroundings – not to mention the fact that they usually substitute black, gray and white for the given color schemes.

In its exploration of the visible world, the camera produces images that differ from painting in two respects. Photographic records evoke

not only esthetic contemplation but also an observant attitude, challenging us to discern minutiae that we tend to overlook in everyday life.

In addition, photographs permit the spectator to apprehend visual shapes in a fraction of the time he would require for a similarly acute apprehension of the actual objects. There are three reasons for this: photographs, by isolating what they present, facilitate visual perception; they transform depth to one plane; and they usually also reduce the angle of vision, thus enabling the eye to comprehend with relative ease whatever is represented.

To the nineteenth century, the unsuspected revelations of photographs were something to marvel at.* Talbot, one of the founding fathers of photography, remarked as early as 1844 that, more often than not, "the operator himself discovers on examination, perhaps long afterwards, that he had depicted many things he had no notion of at the time".[1] With the rise of instantaneous photography it became obvious that the camera is not only extremely inquisitive, but actually transcends human vision. Snapshots (in the technical sense of the word, rather than in the popular meaning of amateur photography) may isolate transitory gestures and configurations which our eye cannot possibly register. In the preface to his book, *Instantaneous Photography* (1895),[2] the English photochemist Abney dwelt on the "grotesqueness" of the numerous snapshots which make you believe "that figures are posed in attitudes in which they are never seen".[3]

But there is a difference between acknowledging the characteristics of a medium and actually taking advantage of them. Nineteenth-century photographers tended to submit to the visual habits and esthetic preferences of society at large. They shrank from exploring the world photographically lest the grotesqueness of their images

* The historical references throughout have largely been drawn from Beaumont Newhall's article, "Photography and the Development of Kinetic Visualization" (*Journal of the Warburg and Courtauld Institutes*, London, 1944, vol. VII, p. 40–45) and his History of Photography (New York, The Museum of Modern Art, 1949).

Antony Samuel Adam-Salomon, Self-Portrait, c. 1860.

might be incompatible with the prevailing artistic traditions. And were they not artists, after all? Instead of defying pre-photographic fashions of seeing, therefore, these artist-photographers deliberately fell back into accepted art styles and time-honored stereotypes. Conspicuous was the case of Adam-Salomon: a sculptor become photographer, he excelled in portraits which, because of their "Rembrandt lighting"[4] and velvet drapery, persuaded the poet Lamartine to recant his initial opinion that photographs were nothing but a "plagiarism of nature."[5] Lamartine now felt sure that they were art. It was the eternal conspiracy of conventional beauty against unwonted truth. That the conventional sold better was all the more in its favor.

The desire for genuinely photographic ventures could not be stilled, however, by any amount of conservatism. Once instantaneous photography was firmly established, an increasing number of devotees of art-photography renounced their prejudices and scruples. This is

illustrated by the dramatic conversion of P. H. Emerson, who, having for a long time emulated painting, in 1891 openly condemned as a fallacy his confusion of photography with art in the traditional sense. In spite of all temptations to the contrary, the urge to capitalize on the camera's ability to record and explore was irrepressible.

What did the photographic approach, sensitive to the potentialities and limitations of the medium, imply for the photographer, his products and the effects of the latter upon the spectator? Proust has drawn an image of the photographer which still vibrates with the nineteenth-century controversy about photography versus art. It is in that passage of *The Guermantes' Way* where the narrator enters the drawing room of his grandmother without having been announced, and finds her seated there reading:

> I was in the room, or rather I was not yet in the room since she was not aware of my presence... Of myself ... there was present only the witness, the observer with a hat and traveling coat, the stranger who does not belong to the house, the photographer who has called to take a photograph of places which one will never see again. The process that mechanically occurred in my eyes when I caught sight of my grandmother was indeed a photograph. We never see the people who are dear to us save in the animated system, the perpetual motion of our incessant love for them, which before allowing the images that their faces present to reach us catches them in its vortex, flings them back upon the idea that we have always had of them, makes them adhere to it, coincide with it. How, since into the forehead, the cheeks of my grandmother I had been accustomed to read all the most delicate, the most permanent qualities of her mind; how, since every casual glance is an act of necromancy, each face that we love a mirror of the past, how could I have failed to overlook what in her had become dulled and changed, seeing that in the most trivial spectacles of our daily life our eye, charged with thought, neglects, as would a classical tragedy, every image that does not assist the action of the play and retains only those that may help to make its purpose intelligible. But if, in place of our eye, it should he a purely material object, a photographic plate, that has watched the action, then

what we shall see, in the courtyard of the Institute, for example, will be, instead of the dignified emergence of an Academician who is going to hail a cab, his staggering gait, his precautions to avoid tumbling upon his back, the parabola of his fall, as though he were drunk, or the ground frozen over… . And, as a sick man who for long has not looked at his own reflection … recoils on catching sight in the glass, in the midst of an arid waste of cheek, of the sloping red structure of a nose as huge as one of the pyramids … I, for whom my grandmother was still myself, I who had never seen her save in my own soul, always at the same place in the past, through the transparent sheets of contiguous, overlapping memories, suddenly in our drawing room which formed part of a new world, that of time, saw, sitting on the sofa, beneath the lamp, red-faced, heavy and common, sick, lost in thought, following the lines of a book with eyes that seemed hardly sane, a dejected old woman whom I did not know.*

Proust starts from the premise that love blinds us to the changes in appearance which the beloved undergoes in the course of time. It is logical, therefore, that he should emphasize emotional detachment as the photographer's foremost virtue. He drives home this point by identifying the photographer with the witness, the observer, the stranger – three types characterized by their common unfamiliarity with the places at which they happen to be. They may perceive anything, because nothing they see is pregnant with memories that would captivate them and thus limit their vision. The ideal photographer, then, is the opposite of the unseeing lover; his eye, instead of being "charged with thought", resembles the indiscriminating mirror or camera lens.

The one-sidedness of Proust's point of view is evident. But the whole context indicates that he was primarily concerned with depicting a state of mind in which we are so completely overwhelmed by involuntary memories that we can no longer register our present

* Marcel Proust, *The Guermantes' Way,* Part I, New York. Modern Library, 1925, p. 186–188.

surroundings to the full. And his desire to contrast, for the purpose of increased clarity, this particular state of mind with the photographic attitude, may have induced him to adopt the credo of the naive realists – that what the photographer does is to hold a mirror up to nature.

Actually there is no mirror at all. Any photograph is the outcome of selective activities which go far beyond those involved in the unconscious structuring of the visual raw material. The photographer selects deliberately both his subject and the manner of presenting it. He may prefer inanimate objects to portraits, outdoor scenes to interiors; and he is relatively free to vary and combine the different factors upon which the final appearance of his product depends. Lighting, camera angle, lens, filter, emulsion and frame – all these are determined by his estimates, his esthetic judgment. Discussing the pictures Charles Marville took of doomed old Paris streets and houses under Napoleon III, Beaumont Newhall traces their "melancholy beauty" to Marville's personality, which no doubt was responsible for the knowing choice of stance, time and detail. "Documentary photography is a personal matter",[6] he concludes. Contrary to Proust's assertion, the photographer's eye is also "charged with thought".

And yet Proust is basically right in relating the photographic approach to the psychological state of alienation. For even though the photographer rarely shows the emotional detachment Proust ascribes to him, neither does he externalize his personality, but draws on it mainly for the purpose of making his account of the visible world all the more inclusive. His selectivity is empathic rather than spontaneous; he resembles not so much the expressive artist who wants to project his visions, as the imaginative reader who tries to discover the hidden significance of a given text.

There are, however, cases which at first glance do not fit into this scheme. During the last decades, many a noted photographer specialized in subjects that reflected the pictorial archetypes he found within himself. For instance, the late Moholy-Nagy and Edward Weston concentrated on abstract patterns, featuring form

rather than incident. The photographers in this vein seem to have overwhelmed their material instead of yielding to the impact of existence. Accordingly, their prints are often reminiscent of contemporary paintings or drawings. In this respect they somehow resemble those nineteenth-century artist-photographers who fell into line with the Pre-Raphaelites and other schools of art of their day. And like their predecessors, these modern photographers may be not only influenced by current art but so deeply imbued with its underlying concepts that they cannot help reading them into every context. Or do they rather discover them in the text? The *Zeitgeist* conditions perception, making the different media of communication approach each other.

Many photographs of this sort are ambiguous. They aim, on the one hand, at effects which might as well be obtained by the painter's brush – in fact, some of them look exactly like reproductions of works of art; on the other hand, they seem primarily concerned with certain aspects of unadulterated nature. Fascinating border cases, these photographs result from two conflicting tendencies – the desire to project inner images and the desire to record outer shapes. Obviously they are genuine photographs to the extent to which they follow the latter inclination. Their specifically photographic value lies in their realistic quality. It is noteworthy that Edward Weston, who wavered between those two tendencies, increasingly rejected the idea of photography as a means of self-projection. "The camera must be used for recording life", he remarked in his *Daybook*, "for rendering the very substance and quintessence of the thing itself … I shall let no chance pass to record interesting abstractions, but I feel definite in my belief that the approach to photography is through realism".[7] His statement would seem all the more conclusive since he himself had emphasized abstraction.

The photographic approach – that is, the effort to utilize the inherent abilities of the camera – is responsible for the particular nature of photographs. In the days of Zola and the Impressionists, the properties of photographs were commonly held to be the hallmarks of art in general; but no sooner did painting and literature break away

Edward Weston, Rock Erosion, 1935.

from realism than these properties assumed an exclusive character. Since they depend upon techniques peculiar to the medium, they have remained stable throughout its evolution. These properties may be defined as follows:

First, photography has an outspoken affinity for unstaged reality. Pictures which impress us as intrinsically photographic seem intended to capture nature in the raw, nature unmanipulated and as it exists independently of us. Sir John Robison, a contemporary of Daguerre, praised the first photographs for rendering "a withered leaf lying on a projecting cornice, or an accumulation of dust in a hollow moulding ... when they exist in the original."[8] And Talbot, in an attempt to condition public taste to the new photographic themes, invoked the precedent of many a painting immortalizing such ephemeral subjects as a "casual glance of sunshine, ... a time-withered oak, or a moss-covered stone".[9] It is true that in the field of portraiture photographers frequently interfere with the given conditions to bring out what they consider the typical feature of a human

Laszlo Moholy-Nagy, From Berlin Wireless
Tower, 1928.

face. But the boundaries between staged and unstaged reality are
fluid in this field; and a portraitist who provides an adequate set-
ting or asks his model to lower the head a bit, may well be helping
nature to manifest itself forcibly. What counts is his desire to do
precisely this – to catch nature in the act of living without imping-
ing on its integrity. If the "expressive artist" in him gets the better
of the "imaginative reader", he will inevitably transgress the limit
that separates a photograph from a painting.

Second, through this concern with unstaged reality, photography –
especially instantaneous photography – tends to stress the fortu-
itous. Random events are the very meat of snapshots; hence the
attractiveness of street crowds. By 1859, New York stereographs
took a fancy to the kaleidoscopic mingling of vehicles and pedes-
trians, and somewhat later Victorian snapshots reveled in the same
inchoate patterns. Dreams nurtured by the big cities thus material-

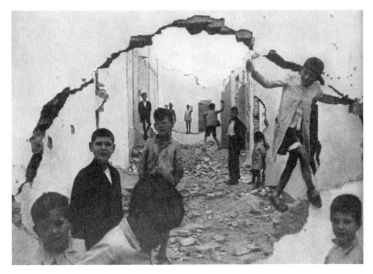

Henri Cartier-Bresson, Children Playing in the Ruins, Spain, 1933.

ized as pictorial records of chance meetings, strange overlappings and fabulous coincidences. Even the most typical instantaneous portrait retains an accidental character. It is plucked in passing and still quivers with crude existence.

Third, photographs tend to suggest infinity. This follows from their emphasis on fortuitous combinations which represent fragments rather than wholes. A photograph, whether portrait or action picture, is true to character only if it precludes the notion of completeness. Its frame marks a provisional limit; its content refers to other contents outside that frame, and its structure denotes something that cannot be encompassed – physical existence. Nineteenth-century writers called this something nature, or life; and they were convinced that photography would have to impress upon us its endlessness. Leaves, which they considered the favorite motive of the camera, are not only not susceptible to being staged, but they also occur in infinite quantities. There is an analogy between the photographic

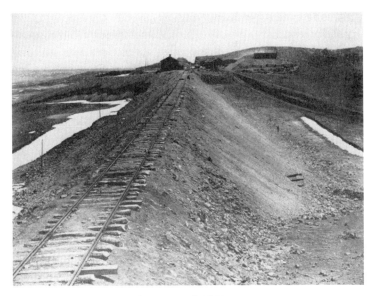

A. J. Russell, Granite Canyon in Foreground, 1867.

approach and scientific investigation in this respect: both probe into an inexhaustible universe, whose whole forever eludes them.

Finally, photographs tend to be indeterminate in a sense of which Proust was keenly aware. In the passage quoted above, he contends that the photograph of an Academician about to hail a cab but hampered in his movements, staggering in his gait, will not convey the idea of his dignity so much as it will highlight his awkward efforts to avoid slipping. Obviously Proust has snapshots in mind. The snapshot of the Academician does not necessarily imply that its original must be thought of as being undignified; it simply fails to tell us anything specific about his general behavior or his typical attitudes. It so radically isolates his momentary pose that the function of this within the total structure of his personality remains anybody's guess. The pose relates to a context which itself is not given. The photograph thus differs from the work of art in transmitting material

73

without defining it. No doubt Proust exaggerates the indeterminacy of photographs just as grossly as he does their depersonalizing quality. In effect, the photographer endows his pictures with structure and meaning to the extent to which he makes significant choices. His pictures record nature and at the same time reflect his attempts to decipher it. Yet, as in depicting the photographer's alienation, Proust is again essentially right, for however selective true photographs are, they cannot deny the tendency towards the unorganized and diffuse which marks them as records. If this tendency were defeated by the artist-photographer's nostalgia for meaningful design, they would cease to be photographs.

Since the days of Daguerre, people have felt that photographs are products of an approach which should not be confused with that of the artist but should be founded upon the camera's unique ability to record nature. This explains the most common reaction to photographs: they are valued as documents of unquestionable authenticity. It was their documentary quality which struck the nineteenth-century imagination. Baudelaire, who scorned both art's decline into photography and photography's pretense to art, at least admitted that photographs had the merit of rendering, and thus preserving, all those transient things which were entitled to a place in the "archives of our memory".[10] Their early popularity as souvenirs cannot be overestimated. There is practically no family which does not boast an album crowded with generations of dear ones before varying backgrounds. With the passing of time, these souvenirs undergo a significant change in meaning. As the recollections they embody fade away, they assume increasingly documentary functions; their value as photographic records definitely overshadows their original appeal as memory aids. Leafing through the family album, the grandmother will re-experience her honeymoon, while the children will curiously study bizarre gondolas, obsolete fashions and old young faces they never saw.

And most certainly they will rejoice in discoveries, pointing to odd bagatelles which the grandmother failed to notice in her day. This too is a typical reaction to photographs. People instinctively look

Eliot F. Porter, Road Runner, 1941.

at them in the hope of detecting something new or unexpected – a confidence which pays tribute to the camera's exploring faculty. The American writer and physician Oliver Wendell Holmes was among the first to capitalize on this faculty in the interests of science. In the early 1880s he found that the movements of people walking, as disclosed by instantaneous photography, differed greatly from what artists had imagined them to be like, and on the grounds of his observations criticized an artificial leg then popular with amputated Civil War soldiers. Other scientists followed suit, using the camera as a means of detection. In selecting illustrations for *The Expression of the Emotions in Man and Animals*,[11] Darwin preferred photographs to works of art, and snapshots to time exposures. Photography was thus recognized as a tool of science.

And, of course, it was always recognized as a source of beauty. Yet beauty may be experienced in different ways. Under the impact of deep-rooted esthetic conventions many people, who undoubtedly acknowledged the documentary quality of photographs, nevertheless expected them to afford the kind of satisfaction ordinarily derived from paintings or poems – a blending of photography with the established arts. Because of the affinity between photography and the other arts, there is in fact an unending procession of artist-photographers.

But this confusion was never shared by the more sensitive – those really susceptible to the photographic approach. All of these rejected the esthetic ideal as the main issue of photography. In their opinion, the medium does not primarily aspire to artistic effects; rather, it challenges us to extend our vision, and this precisely is its beauty. According to Talbot, one of the charms of photographs consists in the discoveries to which they invariably lend themselves. "In a perfect photograph", said Holmes, "there will be many beauties lurking, unobserved, as there are flowers that blush unseen in forests and meadows".[12] Like Talbot, he considered the esthetic value of photographs a function of their explorative powers; photographs, his statement implies, are beautiful to the extent to which they reveal things that we normally overlook. Similarly, Louis Delluc, one of the greatest figures of the French cinema after World War I, took delight – esthetic delight – in the surprising revelations of Kodak pictures.

This is what enchants me: you will admit that it is unusual suddenly to notice, on a film or a plate, that some passerby, picked up inadvertently by the camera lens, has a singular expression; that Mme. X … preserves the unconscious secret of classic postures in scattered fragments; and that the trees, the water, the fabrics, the beasts achieve the familiar rhythm which we know is peculiar to them, only by means of decomposed movements whose disclosure proves upsetting to us.[*]

[*] Louis Delluc, *Photogénie*, Paris, M. De Brunoff, 1920, p. 5. [Reprint in Simpson, P., Utterson, A. & Shepherdson, K. J. (eds.) *Film Theory: Critical Concepts in Media and Cultural Studies* (London, Routledge, 2004) pp. 49–51.]

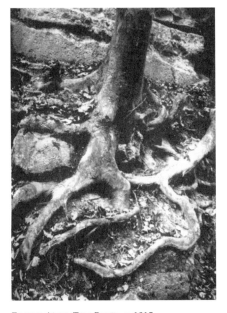

Eugene Atget, Tree Roots, c. 1915.

What enchanted Delluc in a photograph was the presence of the unforeseeable – that which is in flagrant contradiction to artistic premeditation.

These statements indicate the close relationship that exists between our esthetic experience of photographs and our interest in them as observers, if not scientists. Photographs evoke a response in which our sense of beauty and our desire for knowledge interpenetrate; and often they seem esthetically attractive because they satisfy that desire.[13]

Magazine of Art, March 1951

Maria Zinfert

Curriculum Vitae in Pictures

There is an envelope in the Deutsches Literaturarchiv in Marbach bearing the inscription "Curriculum Vitae / in pictures (Friedel)". It is part of the Siegfried Kracauer estate. The writing is in the hand of his wife Elisabeth,[1] known as 'Lili'; among those close to him, Kracauer was called "Friedel".[2] The envelope does not, however, offer a faithful biography in images of the latter – for it is empty. The inscription invites one certainly to try a reconstruction which can, however, hardly be undertaken seriously. The only reference to a "curriculum vitae in pictures" is this empty envelope. Whether it ever contained photographs is difficult to establish,[3] and it is therefore not excluded that it is only evidence of a project that was not carried out or that was begun but remained unfinished. Whatever it be, one thing is certain: the expression 'curriculum vitae in pictures' is a reference to a "Bildertext", a "text in images".[4]

The archive photos chosen here, and presented in chronological order, can be read as a fragmentary and provisional curriculum vitae.[5] But this cannot be made up only of images. The textual commentaries provide the biographical information that corresponds to the images, although the subject of the commentaries is the images *per se*. What these reveal about themselves is what reproductions of photographic print-runs reveal. The iconographical material presented here offers a glimpse of the photographic contents of the Kracauer estate. Being archival material, these photos are, by virtue of their status and function, something other than what they were

Ill. 1. Frankfurt am Main, 1897, Atelier Collischonn; paper print on cardboard, 6.5 x 10.5 cm.

for Kracauer himself. They are no longer situated on yesterday's border. They have become historical. Archival research interrogates the photographs in as much as they are seen as concrete traces in their various dimensions. What follows can only give a glimpse of these.

Frankfurt am Main 1889–1918

Only about ten photos from Kracauer's childhood and youth survive in the archive. They were taken in Frankfurt studios, and mounted on cardboard. Only one of them shows Kracauer with someone else: he has been photographed in Herman Collischonn's studio against a bright background wearing a dark suit and a sailor's collar, beside his mother Rosette Kracauer[6] (Ill. 1). There are no amateur snapshots from this period of youth. The studio photos hardly provide any personal information. To someone looking at them today, the external appearance of the people photographed dissolves into "old-fashioned details of fashion".[7] The background is

Ill. 2. Frankfurt am Main, 1904,
Atelier Erna; paper print on cardboard,
11.5 x 5.5 cm.

pure theatre backdrop. The objects placed in the image are common-
place accessories. The pedestal table on which the young Kracauer
seems to lean in the Atelier Erna studio (Ill. 2), is similar to those
countless, identical tables used over the course of the decades in
all the portrait studios. This pedestal table, an inheritance from the
first era of photography when significant exposure times justified
its presence, still had its place at the beginning of the twentieth cen-
tury – but only as a decorative element in a conventional composi-
tion. Photographs of this period aimed for the most part to produce

Ill. 3. Italy [?], ca. 1912, unknown
photographer; paper print of the reproduction
of an identity photo, 26 x 20 cm.

worthy souvenirs of key biographical events. The portrait of the
adolescent was perhaps taken on the occasion of Kracauer's enter-
ing the Klinger Oberrealschule in 1904, just as the photo where he
is with his mother could have marked the latter's thirtieth birthday
in the spring of 1897.

The studio photo must have been taken during Kracauer's student
period, between 1907 and 1912;[8] the reproduction here does not
represent an original print but a secondary one, made much later in
New York (Ill. 3). The cachets that can be seen in the corners indi-
cate that the positive print used for the enlargement had served as
an identity photo. It is to be found on a pass for museums, galleries,
archaeological sites and national monuments that had been issued
to him on a journey to Italy in 1912. Some of the twelve large-format
reproductions of the New York laboratory Modernage deposited in

Ill. 4. Mainz, 1917, unknown photographer; paper print on cardboard, 8.7 x 13.6 cm.

the archive carry on their back an indication of quality added by Lili Kracauer. She selected two of the prints and explained that they were only to be used if the better prints were exhausted. Their use might have been connected with the project of a "curriculum vitae in pictures". But this is, for the moment, only a hypothesis.

The photograph in which Kracauer can be recognised in the middle of the back row dates from autumn 1917 (Ill. 4).[9] But is it him? Is it not rather "this imagined young man, behind whom he concealed himself"?[10] This is Ginster, the eponymous hero of his autobiographical novel, who suddenly emerges like in an optical trick. Look at the photograph differently, and it is Kracauer who appears, "a skinny, intimidated young man who finds the military life a strain",[11] in a bold mix of reality and fiction. The group photo, carefully composed, places the lieutenant or the sub-lieutenant[12] at the centre of the image, holding a cigar in his right hand; the soldiers around him are manipulating various objects; Kracauer is holding a cigarette in one hand, another soldier has a book, the one at the end on the left has a broomstick, while the one on the right holds a long object that it is difficult to identify, and the others are

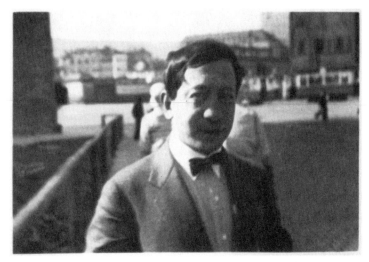

Ill. 5. Frankfurt am Main [?], 1920s, unknown photographer; original paper print, 8.5 x 12.5 cm.

seemingly about to slice bread or polish boots. Who, seeing this, would think of "trench war in its final, most awful phase", of "the monotony of this hell, [of the] permanent vicinity of death"?[13] If the image is related to the reality of the Great War, it is to the extent of serving a strategy of distortion and dissimulation described by Kracauer in Ginster.

Frankfurt am Main 1918–1930 and Berlin 1930–1933

The photographs of Kracauer taken in the 1920s that are in the archive have, it is clear, not entirely broken with the photographic studios. But those reproduced here dating from this period could have been taken by friends or by acquaintances.

The photographic portrait made in the street isolates Kracauer from the outdoor scene that serves as setting: residential buildings

Ill. 6. Dolomites (Italy), 1924, unknown photographer; original paper print
with pencil marks, 9 x 13.5 cm.

can be seen in the blurred background, a tramway, passers-by, it
is a sunny day (Ill. 5). But the scene thus composed is wickedly
eclipsed by the brilliant white pin-on collar that Kracauer wears.
One could write its biography by taking inspiration from his article
in the *Frankfurter Zeitung* on the monocle which "possessed a man
that stuck to it" which even "when the monocle sparkled in the sun,
remained immobile on him".[14]

The view showing Kracauer in a sports jacket, leg warmers and
walking shoes dates from the summer of 1924, and was taken
during a trip to the Dolomites with his friend Theodor Wiesengrund
(Adorno) (Ill. 6). Three people are to be seen: Kracauer on the
left, Wiesengrund on the right[15] and between them a woman. On
the print, two vertical lines detach the part in the middle thereby
separating Kracauer from the two people beside him. These marks
were made for the purposes of an enlargement of the marked-out
section, which is also present in the archive, showing Kracauer on

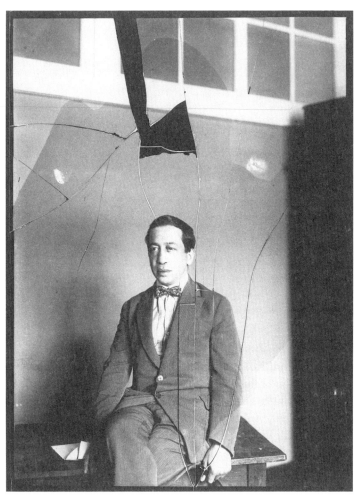

Ill. 7. Frankfurt am Main, second half of the 1920s, unknown photographer; paper print from the archive (DLA) of a broken plate, 17 x 12 cm.

his own, relocated to the right edge, with a flat-gabled building behind him and mountains looming out of the horizon.

A well-known photograph shows Kracauer in a room that it is difficult to identify as a private or institutional space, such as the editorial offices of the *Frankfurter Zeitung*. Everything that surrounds Kracauer in this print, made in the Deutsches Literaturarchiv from a broken photographic plate, appears to be there by chance (Ill. 7). The sides of a tall cupboard projecting its shadow on the wall above which there is a fanlight, Kracauer in front, sitting on a table-top, with an oddly folded sheet of white paper at his side. The original print in the archive, made from the negative glass plate that was still intact, only shows the central section, a head-and-shoulders portrait of Kracauer – all the details on the margins have been eliminated that could have harmed the representation being aimed for: an image suitable for publication.[16] This effacing of the situation in which the shot was taken has the effect of making the photographic medium invisible. As for the print made from the cracked plate, not only does it restore the improvised setting in which the shot was taken, it allows one to also see the damaged plate of glass from which the print was made, thus making "the viewer's glance switch endlessly between the representation and the network of cracks interrupting it".[17]

Ill. 8. Paris [?], 1930, photog. Elisabeth Kracauer;
original paper print, 14 x 9 cm.

France 1933–1938

The portrait, suggesting a shot taken in a studio, was taken in Paris
by his wife Lili Kracauer in 1937 (Ill. 8).[18] It is the fourth of five
similar portraits that are to be seen on the extant original photo-
graphic film and corresponding contact prints. The objects that are
reflected in the table-top are not there by chance. The book, the
pipe, the ashtray, the box of matches, have been intentionally placed
and play their role as the accessories in a succinct setting, showing
Kracauer the author.

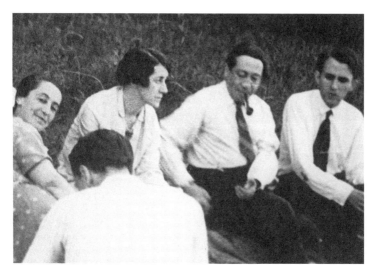

Ill. 9. France, ca. 1934, unknown photographer; original paper print, 5 x 8 cm.

Photos in which Lili and Siegfried Kracauer figure together are rare. Going back to their first years together, there are only a few snapshots that can be dated to 1934/35 and were taken on the occasion of a picnic with friends. In the one reproduced here, Lili Kracauer is in profile, sitting next to her husband (Ill. 9). They had met in Frankfurt am Main before the end of 1925 when she was a librarian at the Institut für Sozialforschung. After their marriage in March 1930, she left her job and became Kracauer's collaborator.[19] Immediately after the burning of the Reichstag, in February 1933, the two of them fled Berlin where they had lived since 1930 and came to Paris.

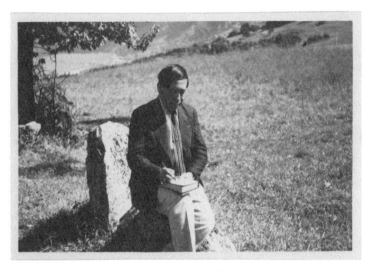

Ill. 10. Combloux (Haute-Savoie), 1934, photog. Elisabeth Kracauer; original paper print, 9 x 14 cm.

From the end of July to the beginning of September 1934, they stayed at Combloux in the Haute Savoie. There are a few photographs dating from this period, that were taken on the occasion of walks in the region. One of them shows Kracauer crossing a meadow, his coat on his right arm, a book in his left hand. In another shot shortly before, the same book serves him as a support. In it, Kracauer is in the process of writing, eyes lowered, sitting on a rock illuminated by the sun (Ill. 10). Under the branches of a tree framing, on the top left, there opens a view of the valley.

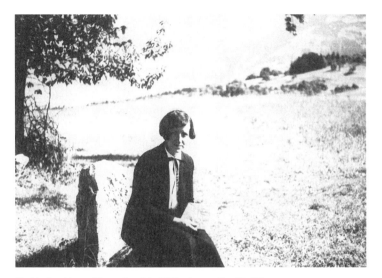

Ill. 11. Combloux (Haute-Savoie), 1934, photog. Siegfried Kracauer; paper print from the archive (DLA), 12 x 17 cm.

An almost identical photo shows Lili at the same spot. Kracauer took it (Ill. 11). If one compares the two images, one could say that the one with Lili has, as it were, slipped from the frame. The equilibrium of the composition where Kracauer appears concentrated on his task, has been lost in the slightly altered position of the camera. The tree that works as a frame in the first image is in the other one nothing but a disorder of branches, without a fixed point; one's gaze peters out in the distance on the mountains on the right. The comparison is not really fair. Lili and Siegfried Kracauer did not stop photographing each other over the course of time. The archive also contains original prints of photos that Kracauer took of his wife, but not of the one reproduced here. This copy is a print made in the archive.

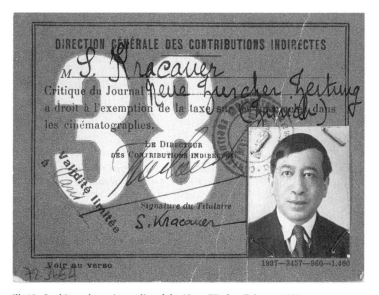

Ill. 12. Card issued as a journalist of the Neue Zürcher Zeitung, 1937,
unknown photographer; original document, 10 x 13 cm.

The Neue Zürcher Zeitung press card, issued in 1937 for access to
French cinemas, does not belong to the specifically photographic
part of the Kracauer estate (Ill. 12). It is unlikely that the identity
photo used for it is one of the portraits made by Lili Kracauer.

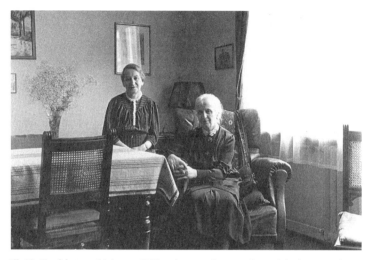

Ill. 13. Frankfurt am Main, ca. 1938, unknown photographer; original paper print, 8.5 x 11.5 cm.

A photo by an unknown photographer, which is to be likewise found in the archive, shows Rosette Kracauer and her sister Hedwig,[20] at the end of the 1930s, in their apartment in Frankfurt am Main (Ill. 13). Despite all his efforts, Kracauer had not succeeded in ensuring the flight from Germany of his mother and his aunt. Both were deported in 1942 to Theresienstadt and shortly after to Poland. They did not survive.

Paris, Marseille, New York 1939–1945

There are no photographs of the period which goes from the end of the 1930s to 1945. It is the period of the flight from Europe, held up in fact by all sorts of obstacles,[21] and of a difficult start in New York after the arrival of Lili and Siegfried Kracauer in April 1941.

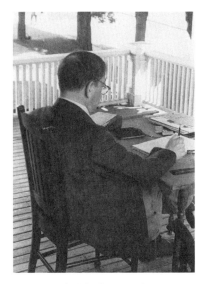

Ill. 14. Stamford (NY), 1950, photog.
Elisabeth Kracauer; original paper print,
12 x 8 cm.

New York 1945–1966

The last photographs of this provisional curriculum vitae were taken,
like most of the portraits conserved in the archive, on trips and out-
doors. The shot, taken in the summer of 1950 at Stamford (N.Y.),
shows Kracauer sitting at a small table on a wooden verandah
(Ill. 14). He is photographed from a slightly high angle, in such a way
that his silhouette is completely captured while his face can hardly be
seen. He seems absorbed in his work, pencil in hand, and is looking
at a pile of papers placed in front of him. The composition, as well
as the elements of the image, suggest strongly that Lili Kracauer was
inspired by the well-known motif of the *studiolo* in the representa-
tion of authors. It is certain this motif frequently found in painting,

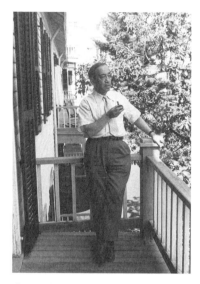

Ill. 15. Lake Minnewaska (NY), first half
of the 1950s; photog. Elisabeth Kracauer;
original paper print, 8 x 5 cm.

and taken up by photography, was familiar to her.[22] An echoing of
this motif, however, is rare in other photos taken by her of Kracauer
at work. It is difficult to draw a clear line between her photographic
practice and the critique of the medium being made by Kracauer.
For him, integral "to the photographer's tact" was "the reduction
to the minimum of any unavoidable stylisations with painting-like
effects".[23]

The photo taken in the first half of the 1950s at Lake Minnewaska
(N.Y.)[24] is not affected by a tradition of this kind, and can be consid-
ered a typical holiday photo (Ill. 15). Pipe in hand, Kracauer poses
in an almost nonchalant attitude on a balcony, opposite the camera,
with his face in three-quarter profile, looking into the distance.

Ill. 16. New York, second half of the 1950s, unknown photographer; Polaroid, 6 x 8 cm.

There do not exist in the archive any prints of photos actually taken in New York, apart from a few identity photos. Almost the only exception is this snapshot, a small format Polaroid, which shows the Kracauers with Maya Deren. On the back of the photograph, someone has noted the name of Deren (Ill. 16a). Lili Kracauer, who can be seen in the background, seems to be greeting someone who is hidden by Maya Deren, who is approaching Kracauer (Ill. 16). The moment that is captured is so alive that one has the impression of having not a photo under one's eyes but rather one of those "snapshots ('picture frames') of which [a film] consists" which are completely absorbed by "the 'shot' — the smallest unit of a film".[25] The impression is reinforced by the element of blurring in the movement and by the characteristic smears of a Polaroid, which allow the materiality specific to the medium to come into view. The Polaroid is comparable to the print from the broken glass plate to

Ill. 16a. Back of the Polaroid with handwritten notes and the stamp of the archive (DLA Marbach).

the extent that here also one's gaze switches back and forth between the representation and the marks of its suspension. The material reality of the image also allows the photo to be approximately dated. Polaroids with a 64x83mm format were only commercialised from 1954 on. Taking account also of biographical information about Maya Deren,[26] the snapshot must date from the second half of the 1950s.

Ill. 17. Klosters (Switzerland), 1960, photog. Elisabeth Kracauer [?]; taken from a
contact sheet in the archive (DLA) of the original Kodak film roll.

Ill. 17a. Klosters (Switzerland), 1960,
photo No. 29 of the same contact sheet,
4 x 3.5 cm.

It was at Klosters, near Davos in Switzerland, that this series of photos was taken (Ill. 17).[27] If all the portraits of Kracauer in the archive were to be lined up alongside each other, one would notice that the same elements appear repeatedly. The poses adopted through the years, and the decades, of collaboration with his wife vary very little.

One can see a typical portrait of Kracauer in the unsuccessful shot No. 29 (Ill. 17a) of this roll of film exposed and developed at Klosters. It stands out in the contact sheet from the photos surrounding it. All have by way of background the same structure of dark, needlework-like lines and of clearer surface areas: it is the amorphous pattern of the wallpaper in front of which Kracauer appears only partially captured by the camera. Assuming that this was an attempt to make a conventional photographic portrait, clearly these shots are by and large unsuccessful. They are blurred, suffer most of the time from a bad exposure and are poorly framed. But as documents that bear witness to the photographic practice of Lili and Siegfried Kracauer, the contact sheet, and particularly photo No. 29, are of considerable

interest. In contrast to the other eleven portrait busts of the series, one is a three-quarter length portrait in a pose that Kracauer commonly took when he was being photographed. Although his body is straight opposite the camera, his folded arms and hands on his knee produce an image of someone who is self-contained and is waiting.

When he was being photographed, Kracauer seems to avoid any assertive or definite attitude. He rarely looks at the camera; most of the time, his gaze is directed at an unspecified object, outside the frame of the image. This is also the case in the portrait shot in 1964 in Rome: Siegfried Kracauer in the ruins of the Forum Romanum (Ill. 18).

Postscript

History. The Last Things before the Last was unfinished when Kracauer died in a New York hospital in November 1966.[28] Mention is found in his correspondence of a work that was never undertaken: "These last weeks, Lili and I have organised all kinds of old documents which lay unsorted in two cases from Paris. We were genuinely overcome: the past revisited, *le temps retrouvé*... But the main point is that this rooting around in the past, with all the letters among the papers, aroused in me an irresistible desire to write my memoirs – I mean, write them really in the grand style. But that will be a luxury that I will probably never be able to afford."[29]

Ill. 18. Rome, 1964, photog. Elisabeth Kracauer; original paper print, 17,5 x 11 cm.

Notes

Kracauer as Thinker
of the Photographic Medium

1 See among other works Siegfried Kracauer, *Die Angestellten. Aus dem neuesten Deutschland*, Frankfurt am Main: Societäts-Druckerei, 1930, pp. 20–21, trans. *The Salaried Masses: Duty and Distraction in Weimar Germany*, trans. Quintin Hoare (London, UK; New York, NY: Verso, 1998), p. 32; *Theory of Film. The Redemption of Physical Reality*, New York: Oxford University Press, 1960 (reprint Princeton, N.J. : Princeton University Press, 1999), p. 3–23; *History. The Last Things Before the Last*, New York: Oxford University Press, 1969 (reprint Princeton : Markus Wiener, 1995), p. 3–4.

2 See the facsimile of the front page of the *Frankfurter Zeitung* where the article appears 'under the line', in the bottom third dedicated to cultural comment, p. 26 of this volume; re-edited in Kracauer, *Das Ornament der Masse: Essays*, Frankfurt am Main: Suhrkamp, 1963, pp. 21–39, trans. "Photography", in *The Mass Ornament*, ed. Thomas Y. Levin (Cambridge, Massachusetts; London, England: Harvard University Press 1995), pp. 47–63.

3 The photographs of the Tiller girls or of the famous actresses of 1927 reproduced in the *Berliner Illustri[e]rte Zeitung*, as well as the photograph of the opera singer Hortense Schneider in crinoline of the 1860s are not those, probably fictional, to which Kracauer refers in his essay. The material chosen here provides, however, the precise iconographical context within which he worked.

4 On the implicit reference here to Bergson see Inka Mülder-Bach, "The Exile of Modernity. Kracauer's Figurations of the Stranger", in *Culture in the Anteroom: The Legacies of Siegfried Kracauer*, ed. Gerd Gemünden and Johannes von Moltke (Ann Arbor: The University of Michigan Press 2012) p. 283.

5 Kracauer is in this period close to a negative and catastrophic vision of history similar to that which Benjamin will develop in his Paris decade, or later Horkheimer and Adorno in *The Dialectic of Enlightenment* (1944). He will distance himself from it later as his American works, dedicated to cinema and historiography, show. See Philippe Despoix, *Ethiken der Entzauberung. Zum Verhältnis von ästhetischer, ethischer und politischer Sphäre am Anfang des 20. Jahrhunderts*, Bodenheim: Philo Verlagsgesellschaft, 1998, in particular p. 202–203.

6 See the eponymous essay "The Mass Ornament", in *The Mass Ornament*, pp. 75–87.

7 The cover of the *Berliner Illustri[e]rte Zeitung.* No. 40, 2[nd] October 1927 (Ill. 4) represents Marshall von Hindenburg whose birthday was being celebrated at the time. On the last page of this issue there are, among other shots, photos of actresses on the beach, one of them on the Lido at Venice. Kracauer publishes his own article in the *Frankfurter Zeitung* on 28th October, against the backdrop, then, of current events.

8 See Walter Benjamin, "Nichts gegen die 'Illustrierte'", *Gesammelte Schriften*, Frankfurt am Main: Suhrkamp, vol. IV, sub-volumes 1–2, 1982, p. 449; the text was sent at the end of 1925 to *Die Literarische Welt* but was not published.

9 Benjamin, "Kleine Geschichte der Photographie" (1931), trans.: "Little History of Photography" in *Walter Benjamin: Selected Writings*, Volume 2, 1927–1934, trans. Rodney Livingstone *et al.*, ed. Michael W. Jennings *et al.*, (Cambridge, Mass.: The Belknap Press of Harvard University Press, 1999), p. 514. Compare with "Photography", p. 40 of this volume.

10 See "Warburgs Ansprache in Hamburg, KBW, Drei-Hüter-Feier", in *Wanderstrassen der Kultur. Die Aby Warburg – Fritz Saxl Korrespondenz 1920 bis 1929*, ed. Dorothea McEwan, Hamburg: Dölling und Gallitz 2004, p. 205–206; see also Aby Warburg, *Der Bilderatlas Mnemosyne*, Berlin: Akademie Verlag, 2003, plates C, 77 and 79. For the later contact of Kracauer with the Warburg

Institute, see *Siegfried Kracauer, Erwin Panofsky. Briefwechsel 1941–1966*, ed. Volker Breidecker, Berlin: Akademie Verlag, 1996, in particular p. 107–108.

11 This exhibition relied on private collections and archives and is not to be confused with the famous international exhibition "FIFO" ("Film und Foto" Ausstellung) which was organized by the Deutscher Werkbund in Stuttgart in 1929 and which travelled under a similar title, in Germany and beyond.

12 Henny Porten (1890–1960) is considered, with Asta Nielsen, to be one of the leading German stars of silent cinema; her career in it began in 1911.

13 See August Sander, *Antlitz der Zeit; sechzig Aufnahmen deutscher Menschen des 20. Jahrhunderts*, mit einer Einleitung von Alfred Döblin, Munich: Kurt Wolff/Transmare Verlag, 1929; trans.: *Face of our Time: Sixty Portraits of Twentieth-Century Germans*, Munich: Schirmer/Mosel, 1994.

14 See Helmar Lerski, *Köpfe des Alltags; Unbekannte Menschen*, Berlin: Verlag H. Reckendorf, 1931; and, among other places, Kracauer, *Theory of Film*, pp. 161–162.

15 "'Marseiller Entwurf' zu einer Theorie des Films", in S. Kracauer, *Werke. Theorie des Films*, ed. Inka Mülder-Bach, Frankfurt am Main: Suhrkamp, vol. 3, 2006, p. 533–534.

16 Ibid., p. 563.

17 Beaumont Newhall "Photography and the Development of Kinetic Visualization", in *Journal of the Warburg and Courtauld Institutes*, London, vol. 7, 1944, pp. 40–45; and *The History of Photography. From 1839 to the Present Day*, New York: The Museum of Modern Art, 1949.

18 Benjamin had translated, with Franz Hessel, Marcel Proust, *A l'ombre des jeunes filles en fleurs* (*Im Schatten der jungen Mädchen*, Berlin, Die Schmiede, 1927) and *Le côté de Guermantes* (*Die Herzogin von Guermantes*, Munich, R. Piper, 1930) where is to be found the quotation given by Kracauer on the photographic shock of the narrator facing his grandmother. See also on this hypothesis: Carlo Ginzburg, "Minutiae, Close-up, Microanalysis", in *Critical Inquiry*, vol. 34, No. 1 (Autumn 2007), p. 179. In the copy of Proust, *Remembrance of Things Past* (two-vol. edition, New York: Random House, c. 1934) in the personal library of Kracauer (kept in Special Collections at the Deutsches Literaturarchiv Marbach), there are seven pages of handwritten notes on the novel, of which one page is dedicated to the passages on photography.

19 Kracauer will describe in *Theory of Film*, p. 16, how "The photographer summons up his being, not to discharge it in autonomous creations but to dissolve it into the substances of the objects that close in on him".

20 See the first two reproductions in *The Magazine of Art*: Fox Talbot, *The Open Door* (facsimile of *The Pencil of Nature*, 1844) and Antony Samuel Adam-Salomon, *Self-Portrait* (c. 1860), p. 62 and p. 65 of this volume.

21 Kracauer is referring to the following photographs: Edward Weston, *Rock Erosion* (1935); Laszlo Moholy-Nagy, *Vom Berliner Funkturm* (1928); Henri Cartier-Bresson, *Enfants dans les ruines* (1933); A. J. Russell, *Granite Canyon in Foreground* (1867); Eliot F. Porter, *Road Runner* (1941) and Eugène Atget, *Racines* (c. 1915) also reproduced in *Magazine of Art*, pp. 70–77 of this volume.

22 See Kracauer, *Theory of Film*, p. 17 and Ill. 11 (Eugène Atget, *Rue Saint-Rustique*, 1922).

23 Ibid., pp. 300–301.

24 Carlo Ginzburg, "Minutiae, Close-up, Microanalysis", p. 178.

25 Ibid., p.179.

26 See in particular on this point Heide Schlüpmann, "Stellung zur Massenkultur", in Schlüpmann, *Ein Detektiv des Kinos. Studien zu Siegfried Kracauers Filmtheorie*, Basel; Frankfurt am Main; Stroemfeld: 1998, pp. 55–65; and Myriam Hansen, "Kracauer's Photography Essay. Dot Matrix – General (An-)Archive – Film" *in Culture in the Anteroom. The Legacies of Siegfried Kracauer*, eds. Gerd Gemünden, Johannes von Moltke, Ann Arbor: The University of Michigan Press, 2012, pp. 93–110.

27 The Kracauer estate was bequeathed by his widow Lili Kracauer to Brandeis University. One year after her death, in 1972, the estate was bought by the Deutsches Literaturarchiv, Marbach am Neckar. It is difficult to reconstruct at what moment the photos probably assembled in the envelope may have been scattered. The photographic material in the estate has now been made the subject of a book, Maria Zinfert (ed.), *Kracauer. Photographic Archive*, Zürich: diaphanes, 2014.

28 See on this subject among others Nia Perivolaropoulou, "Zeit der Geschichte und Zeit des Films bei Siegfried Kracauer", in *Film als Loch in der Wand. Kino und Geschichte bei Siegfried Kracauer*, eds. Drehli Robnik, Amália Kerekes, Katalin Teller, Vienna; Berlin: Verlag Turia + Kant, 2013,

pp. 146–159 ; see also Philippe Despoix, "Geschichstschreibung im Zeitalter fotografischer und filmischer Reproduzierbarkeit", in the above volume, pp. 103–115.

29 See "The Biography as an Art Form of the New Bourgeoisie", *in The Mass Ornament*, pp. 101–105; and Kracauer, *Jacques Offenbach and the Paris of His Time,* foreword by Gertrud Koch, trans. Gwenda David and Eric Mosbacher, New York: Zone Books, distributed by MIT Press, Cambridge, Mass., 2002, p. 23; see also Kracauer, *History. The Last Things before the Last*, New York, Oxford University Press, 1969, pp. 3–4.

30 See the letters to Adorno of 25th Oct. and 8th Nov. 1963, in *Theodor W. Adorno / Siegfried Kracauer, Briefwechsel 1923–1966*, ed. Wolfgang Schopf, in *Theodor W. Adorno, Briefe und Briefwechsel*, vol. 7), Frankfurt am Main: Suhrkamp, 2008, pp. 611–612 and p. 621.

31 Letter to Adorno of 1st Oct. 1950, ibid., p. 449; see also Maria Zinfert's commentary in "Curriculum Vitae in Pictures" at the end of this volume, p. 101.

Photography

1 A classic children's fairy tale, "Das Märchen vom Schlaraffenland" by the brothers Grimm was included in their *Kinder- und Hausmärchen* from the second edition of 1819 ; compare the translation with (§158) "The Story of Schlauraffen Land [The Tale About the Land of Cockaigne]", in *Grimm's Fairy Tales* (New York: Pantheon Books 1944), pp. 660–661.

2 A troupe of dancing girls created in 1890 by John Tiller in Manchester that had significant international success from the 1920s. Kracauer also evoked them in his essay "Das Ornament der Masse" that appeared in June 1927, which was taken as the title for the essay collection published subsequently by Suhrkamp in 1963; trans.: "The Mass Ornament", in *The Mass Ornament*, ed. Thomas Y. Levin (Cambridge, Massachussetts, London, England: Harvard University Press 1995), pp. 75–87.

3 In the original text Kracauer adds here between hyphens: "Dilthey among others", a reference that will be dropped when the essay is re-published in the volume *Das Ornament der Masse* in 1963. Wilhelm Dilthey (1833–1911)

was a German historian, psychologist and philosopher, biographer of the young Hegel and commentator of Goethe who played an important role in the development of a "historicising" conception of the human sciences as well as of hermeneutics. Kracauer will return to this author in his posthumous fragment *History. The Last Things Before the Last*, New York, Oxford University Press, 1969.

4 Allusion to a legendary medieval figure, brought back into currency by Ludwig Tieck and Goethe.

5 The underlining is Kracauer's; cf. Johann Wolfgang von Goethe, "J. P. Eckermanns Gespräche mit Goethe. 18. April 1827", in *Sämtliche Werke* (Münchner Ausgabe), ed. Heinz Schlaffer, vol. 19, Munich, Vienna, Carl Hanser Verlag, 1986, pp. 559–560; trans. *Conversations of Goethe with Eckermann and Soret*, trans. John Oxenford (London: George Bell & Sons, revised edition 1901), p. 248.

6 Wilhelm Trübner (1851–1917): professor at the Academy of Karlsruhe, a portrait painter and a painter of naturalist and realist landscapes who later drew close to Impressionism; he belonged to the circle of Munich artists around Wilhelm Leibl.

7 Ludwig von Zumbusch (1861–1927): a painter who came from a family of famous sculptors, author of children's portraits, pastels and landscapes. He was part of the Munich Secession.

8 Ewald André Dupont (1891–1956): one of the pioneers of German cinema, an important director of the Weimar period who had success with feature films such as *Variété* (1925), *Moulin Rouge* (1928), *Piccadilly* (1929) or *Salto Mortale* (1931). Kracauer wrote, from 1923 on, several reviews of these films.

9 Dedicated to avant-garde films, the Studio des Ursulines had opened in 1926 at 10 rue des Ursulines in Paris.

10 Kracauer is referring to Wilhelm Marx (1863–1946), a German politician who was a member of the Zentrum party, and was Chancellor between 1926 and 1928.

11 Marshall Paul von Hindenburg (1847–1934) was President of the Republic in 1927. A portrait of him, drawn after a photograph, made, among other places, the cover of the *Berliner Illustri[e]rte Zeitung*, of 2 October 1927, three weeks before the publication of Kracauer's essay.

12 Gustav Stresemann (1878–1929) was the German Minister of Foreign Affairs at the time and Aristide Briand (1862–1932) had the same post in France. In 1926, they had both won the Nobel Peace Prize.

13 Kracauer will propose an analysis of the news in " Die Filmwochenschau" (*Die Neue Rundschau*, Oct. 1932) in *Werke. Kleine Schriften zum Film*, ed. Inka Mülder-Bach, Frankfurt am Main, Suhrkamp, vol. 6.2 (1928–1931), 2004, pp. 553–555.

14 Johann Jacob Bachofen (1815–1897): Swiss historian of law and a classicist and philologist famous for his theory of matriarchy. *Oknos der Seilflechter : Ein Grabbild. Erlösungsgedanken antiker Gräbersymbolik* originally appeared in 1859; partial trans. "Ocnus the Rope Plaiter", in *Myth, Religion, and Mother Right; Selected Writings of J.J. Bachofen* (New Jersey: Princeton University Press 1967), p. 51–65.

15 Karl Marx, "Die deutsche Ideologie. I. Thesen über Feuerbach", in Karl Marx und Friedrich Engels, *Werke*, Berlin, Dietz Verlag, vol. 3, 1978, p. 31 (trans. in *Collected Works of Karl Marx and Friedrich Engels*, 1845–47, vol. 5: *Theses on Feuerbach, The German Ideology and Related Manuscripts*, p. 44).

16 Georg Friedrich Creuzer (1771–1856): German archaeologist and philologist. He is the founder of the scientific study of myths and develops a theory of the symbol set out in the volumes of *Symbolik und Mythologie der alten Völker* (1810–1812). Kracauer is alluding here to the title of his memoirs: *Aus dem Leben eines alten Professors* [Life of an Old Professor] from 1848.

On Yesterday's Border

1 The Berlin exhibition "Film- und Photoschau" had been opened on the 2nd July 1932 in Joachimsthaler Straße under the motto "German mind – German work". It was based on an important collection of the set designer Eduard Andres dedicated to the history of cinema, for which Harry Piel, Max Mack and Fritz Lang, among others, had made available their private archives. Despite the closeness in the title, this permanent exhibition was not connected to the famous international exhibition "FIFO" ("Film und Foto")

in Stuttgart in 1929, which travelled in the following years in Germany as well as abroad.

2 Joseph Nicéphore Niépce (1765–1833): one of the discoverers of photography. He had tried between 1816 and 1820 to fix objects captured by a *camera obscura* on bitumous paper sensitive to light, a procedure that he will extend to the reproduction of etchings on metal and will call "héliographie". He worked from 1826 onwards in collaboration with Louis Jacques Mandé Daguerre (1787–1851) who, exploiting the sensitivity of silver iodide in order to shorten exposure times, will subsequently develop the "daguerreotype", thereby inaugurating the official birth of photography in 1839. The description given by Kracauer of this "photographed" image does not appear to correspond to any of Niépce's surviving works. The "bituminous paper" does, however, indeed point to the beginnings of heliography. Perhaps this *Window* was one of the matching images of *Point of View taken from the Window of Gras* (1826–27), which appears to use bitumen on tin and was only found in 1952.

3 A machine that came from the first cinematographic experimentations, like the phenakistiscope invented by the Belgian Joseph Plateau (1832), the zoetrope of the English mathematician William George Horner (1834) or the praxinoscope of the Frenchman Émile Reynaud (1877).

4 On the eve of the First World War, the Biofix laboratory proposed, followed by others, the production of an original flip book made by photographing the person or people who wished to have it.

5 Max Skladanowsky (1863–1939): pioneer of early cinema who developed, with his brother Emil, the "bioscope". In November 1895, they projected in the Wintergarten in Berlin the first cinematographic takes by using this machine (that is to say, less than two months before the Lumière brothers in Paris); they thereby inaugurated the first projections of moving images to a paying public in Germany.

6 *Eine Fliegenjagd oder Die Rache der Frau Schultze* (*A Fly Chase or the Revenge of Mrs. Schulze*, 1905) of Max Skladanowsky is no longer considered to be the first fiction film in the history of cinema.

7 *Die Rache der Gefallenen* (*The Revenge of the Fallen Woman*, Deutsche Film-Industrie, Robert Glombeck, 1917).

8 Hans Albers (1891–1960): successful German singer and actor who worked in the cinema from 1915. He appeared in, among other films, *Der blaue Engel* (Josef von Sternberg, 1930).

9 Hedwig Courths-Mahler (1867–1950): German author of numerous popular novels the recurrent theme of which is social ascent through love.

10 Henny Porten (1890–1960): famous film actress, was, with Asta Nielsen, one of the first German stars of silent film in which she first appeared in 1911. Kracauer evokes her numerous times in his film reviews from 1923 on.

11 This is a couplet from a very popular tune of the time *Die Rasenbank am Elterngrab* ("The Grassy Bank by my Parents' Grave"); its theme went through multiple versions and it was also the subject of postcards.

12 There seems to be a confusion here between *Sein eigener Mörder* (*His own Murderer*, 1914), not directed by Max Mack, and *Der Andere* (*The Other*, Max Mack, 1913). By taking the leading role in the film, Albert Bassermann (1867–1952) had been one of the first to break the boycott of the cinema by theatre actors in Germany. This feature film, the scenario of which was inspired by Paul Lindau's play *Der Andere: Schauspiel in vier Aufzügen* (1896) and by the theories of Hippolyte Taine developed in his *De l'intelligence* (1870), is considered to be one of the very first German "art" films.

Photographed Berlin

1 Albert Vennemann worked as a photographer in Berlin in the 1920s and at the beginning of the 1930s. He published his photographs in magazines, among others in *Der Querschnitt,* and his works were presented several times in Berlin, such as in the group exhibition "Fotomontage" (1931) or in the exhibition "1000 Berliner Ansichten" about which Kracauer writes here. The Berlin Kunstgewerbemuseum (Arts and Crafts Museum) was housed in the famous building designed by Heino Schmieden and Martin Gropius. It contained important special collections of silverware, glasses, ceramics and textiles, as well as an exhibition of the history of furniture from the Middle Ages to the contemporary period.

A Note on Portrait Photography

1 Apart from the mention of time and place above the article in the *Frank-furter Zeitung* "Berlin, end of January", Kracauer does not identify in any way the exhibition that serves as a pretext for his reflections. The only exhibition of this kind inventoried in Berlin for this period is an exhibition of Hugo Erfurt dedicated to portraits of artists which was entitled "Kün-stlerbildnisse". Erfurt gave a talk in 1933 in Berlin on the theme "Die Ent-wicklung der Bildnis-Photographie" (see Christine Kühn: *Neues Sehen in Berlin. Fotografie der Zwanziger Jahre.* Berlin: Ausstellungskatalog Kunst-bibliothek, Berlin Museum für Fotografie, Staatliche Museen zu Berlin, 2005, p. 255). In this period, photographers like August Sander (*Antlitz der Zeit*, 1929, trans. *Face of our Time: Sixty Portraits of Twentieth-Century Germans,* Munich : Schirmer/Mosel, 1994), whom Kracauer's friend Walter Benjamin had praised in "Kleine Geschichte der Photographie" (1931, trans. "Little History of Photography", in *Walter Benjamin: Selected Writings*, Volume 2, 1927–1934, trans. Rodney Livingstone *et al.*, ed. Michael W. Jennings *et al.*, Cambridge, Mass.: The Belknap Press of Harvard University Press, 1999, pp. 507–530), or Helmar Lerski (*Köpfe des Alltags*, 1931) to whom Kracauer will himself return in *Theory of Film* (1960), had already come to prominence with a modernist, photographic conception of the portrait.

The Photographic Approach

1 Henry Fox Talbot, *The Pencil of Nature*, London, Longman, Brown, Green and Longmans, 1844, p. 40, quoted by Beaumont Newhall, *The History of Photography. From 1839 to the Present Day*, New York, The Museum of Modern Art, 1949, p. 182. (Newhall's *History of Photography* had four editions, in 1937, 1938, 1949 and 1964, and they differ significantly from each other. Kracauer quotes from the third edition of 1949.
2 The quotation seems to come not from the preface but from the first chapter.

3 Sir William de Wiveleslie Abney, *Instantaneous Photography*, New York, Scovill and Adams, 1895, p. 2.

4 Newhall, *The History of Photography*, p. 76.

5 Alphonse de Lamartine, "xxxv^ième entretien. La littérature des sens. La peinture. Léopold Robert. 1^re partie", in *Cours familier de littérature. Un entretien par mois*, Paris, t. 6, 1858, p. 410, quoted in English in Newhall, *ibid*.

6 Newhall, *The History of Photography*, p. 91.

7 Edward Weston, *Daybooks*, Rochester, George Eastman House, vol. 1, 1961, p. 55, quoted in Newhall, *The History of Photography*, p. 157–158.

8 Sir John Robison, « Notes on Daguerre's Photography », in *The Edinburgh New Philosophical Journal*, vol. 27, 1839, p. 155–156, quoted in Newhall "Photography and the Development of Kinetic Visualization", in *Journal of the Warburg and Courtauld Institutes*, vol. 7, 1944, p. 40.

9 Fox Talbot, *The Pencil of Nature*, p. 25–26, quoted in Newhall, *The History of Photography*, p. 40.

10 Charles Baudelaire, "Salon de 1859", in *Critique d'art. Suivi de Critique musicale*, Paris, Gallimard, coll. Folio essais, 1992, p. 278, comp. trans.: "Salon of 1859", in *Baudelaire: Selected Writings on Art and Artists*, trans. P.E. Charvet (Cambridge, Great Britain: Cambridge University Press, 1981) p. 297.

11 See Charles Darwin, *The Expression of the Emotions in Man and Animals*, London, J. Murray, 1872.

12 Oliver Wendell Holmes, "The Stereoscope and the Stereograph", *Atlantic Magazine*, June 1859, quoted in Newhall, "Photography and the Development of Kinetic Visualization", p. 41.

13 The editor of the *Magazine of Art* indicated further on in the notes on contributors to the issue: "The article by SIEGFRIED KRACAUER is condensed from the introductory chapter of a book on film esthetics being prepared with the aid of a grant from the Bollingen Foundation and to be published by Oxford University Press. Dr. Kracauer is the author of *From Caligari to Hitler* (Princeton University, 1947)." The book was published nine years later under the title *Theory of Film. The Redemption of Physical Reality*, New York, Oxford University Press, 1960.

Curriculum Vitae in Pictures

1 Anna Elisabeth Kracauer (née Ehrenreich), born 6 May 1893 in Stras-
bourg, belonged to a Catholic family. All the biographical details come from
documents preserved in the Kracauer estate at the Deutsches Literaturarchiv
Marbach am Neckar (KE DLA).

2 "The official 'Siegfried' is to be ruled out straightaway, and the intimate
'Friedel' dates from a long time ago — [...] Those who still use it loom out
of the past more or less into the present. [...] Please call me Krac"; a letter of
Siegfried Kracauer to Ernst Bloch, early January 1928, quoted in Thomas Y.
Levin, *Siegfried Kracauer. Eine Bibliographie seiner Schriften*, Marbach am
Neckar: Deutsche Schillergesellschaft, collection Verzeichnisse, Berichte,
Informationen, 1989, p. 18.

3 According to the present state of research, the envelope was apparently
empty when it was deposited in the DLA.

4 The expression borrowed from Kracauer refers here to a text in photo-
graphs, corresponding to film where it is a text in animated photographic
images; see also e.g. : "Instead of the words serving to illustrate the text in
images, they lower the images to the level of illustrating the dialogues... ",
S. Kracauer, "Dialog im Film", in *Werke. Kleine Schriften zum Film*, ed. Inka
Mülder-Bach, Frankfurt am Main, Suhrkamp, vol. 6.3 (1932–1961), 2004,
pp. 217. The images of a *curriculum vitae in pictures* would not be depen-
dent, then, on a discursive text (in words) but would form, rather, the first
material of a visual text (in images). See also S. Kracauer, "An der Grenze
des Gestern", in *Werke. Kleine Schriften zum Film,* ed. Inka Mülder-Bach,
Frankfurt am Main, Suhrkamp, vol. 6.3 (1932–1961), 2004, pp. 76–82, here
"On Yesterday's Border", p. 47–53.

5 The provisional selection made here represents only a small part of the
approximately 300 photographs of Kracauer and other people that are con-
served in the archive. For an overall view, see Maria Zinfert, *Kracauer.
Photographic Archive*, Zürich, diaphanes, 2014.

6 Rosette Kracauer was born 2 April at Frankfurt am Main; she was the
daughter of Falk Aron, known as Ferdinand Oppenheim(er), and of his wife
Friederike. In the 1880s she married Adolf Kracauer, born 16 March 1849 at
Sagan; an only child, Siegfried Kracauer, was born on 8 February 1889.

7 S. Kracauer, "Die Photographie"" in *Werke. Essays, Feuilletons, Rezensio-nen*, ed. Inka Mülder-Bach, Berlin, Suhrkamp, vol. 5.2 (1924–1927), 2011, p. 683 (trans.: "Photography", p. 27–45 of this volume).

8 In April 1907, Kracauer began architectural studies in Darmstadt, switched for the autumn to Berlin, went for the summer semester to Munich where he passed his diploma exam in 1911; he finished in July 1914, defending his thesis at the *Technische Hochschule* in Berlin.

9 Kracauer was called up to the infantry at Mayence in mid-September 1917, but was put on reserve as early as November.

10 This is a paraphrase of a formula from Kracauer's autobiographical novel on the period of the First World War, "not him — more some imagined young man, behind whom he hid himself." S. Kracauer, *Ginster, in Werke. Romane und Erzählungen*, ed. Inka Mülder-Bach, Frankfurt am Main, Suhrkamp, vol. 7, 2004, p. 32.

11 Siegfried Kracauer, describing a secondary character, who strikes him above all as "the revolting and robust hero" in the film *West Point* (1927) by Edward Sedgwick; see also S. Kracauer, "Gutes Lustspielprogramm", *in Werke. Kleine Schriften zum Film*, vol. 6.2, p. 209.

12 This is another formula from *Ginster*, borrowed here for lack of the requisite knowledge of military grades.

13 A description of Kracauer's, writing about the film *Westfront 1918* (1930) by G.W. Pabst; S. Kracauer, "Westfront 1918", *in Werke. Kleine Schriften zum Film*, vol. 6.2, p. 360.

14 S. Kracauer, "Das Monokel. Versuch einer Biographie", *in Werke. Essays, Feuilletons, Rezensionen*, vol. 5.2, p. 496, published initially under the pseudonym Raca, in the *Frankfurter Zeitung*, No. 892 of 30th November 1926 (evening edition, comment section).

15 An almost identical photo can be found in the Adorno estate. In it, the two friends are in the same spot, but Theodor Wiesengrund (Adorno) has been moved to where the woman stood, and she has disappeared from the image. Reproduced in: Theodor W. Adorno / Siegfried Kracauer, *Briefwechsel 1923–1966*, ed. Wolfgang Schopf, iconographical document 2, p. 726, Frankfurt am Main, Suhrkamp, 2008. The photo comes with a caption that consists of a quotation that is taken from a letter of Adorno's of the 28th October 1964: "an attempt ought to finally be made here to create a monument to the

figure that together we compose." Adorno, however, is making an allusion not retrospectively to this old photograph but to his article, then very recent, on Kracauer, "Der wunderliche Realist" (trans.: Theodor Adorno, "The Curious Realist: On Siegfried Kracauer", in *Notes to Literature*. vol. 2 (New York; Chichester: Columbia University Press, 1992), pp. 58–75.) Kracauer would not, for his part, have been in as much agreement with the idea of such a monument as the sight of the two hikers side by side might suggest.

16 Kracauer, who became a member of the editorial staff of the *Frankfurter Zeitung* in 1921, gave the photo, among others, in 1930 to the *Reichshandbuch der Deutschen Gesellschaft* for publication purposes; see also the photo's reproduction on the front of *Siegfried Kracauer 1889–1966*, ed. Ingrid Belke and Irina Renz.

17 Peter Geimer, *Bilder aus Versehen. Eine Geschichte fotografischer Erscheinungen*, Hamburg: Philo Fine Arts, coll. Fundus Bücher, 2010, p. 9. Geimer is referring to a well-known photo by André Kertesz, *Broken Plate* (1929), which he places as an emblem at the beginning of his work that is dedicated to "the interaction between the effect and its negation, the image and the perturbation of the image", p. 11.

18 Lili Kracauer is the author of all of the portraits made after their marriage to be found in the Kracauer estate. She used a Leica: there are a number of instruction manuals in Kracauer's library for the Model Leica III, which was commercialised from 1932, and there are also works on photography with a Leica.

19 This can be gleaned from the following declaration that Lili Kracauer wrote in November 1963 for a Berlin authority: "On the 5th March 1930, I got married to Dr. Siegfried Kracauer. In his wide-ranging activities as an editor of the *Frankfurter Zeitung*, as a social scientist [sic!] and as an author, Dr. Kracauer was dependent on collaborators. Thanks to my professional training over many years and in different areas, I was in a position to take over all the work that my husband needed done. My work for him consisted in the search for materials, in the production of excerpts, proof-reading, managing an extensive correspondence, etc." Lili Kracauer, Typed Manuscript, Declaration to a Germany authority, 8th November 1963, (original in German) KE DLA.

20 The two sisters Rosette (1867–1942) and Hedwig (1862–1942) were married to the brothers Adolf (1849–1918) and Isidor (1852–1923) Kracauer.

21 In June 1940, Lili and Siegfried Kracauer were able, after having overcome repeated obstacles, to get from Paris to Marseille. In August, Walter Benjamin also arrived in Marseille, where he met the Kracauers almost every day. After the Spanish government suddenly decided, in September, to prohibit the passage of stateless persons, the way was closed to the last open port, Lisbon. The border had to be crossed using false papers or else by taking difficult paths through the Pyrenees. It is there that Benjamin committed suicide on the 24th September 1940. In February 1941, the Kracauers finally managed to leave Marseille for Lisbon, embarking in April, at the last minute on a ship which carried them safely to New York.

22 Lili Kracauer had studied music and art history at the University of Leipzig at the beginning of the 1920s. On the historical development of the author's portrait, see Michael Diers, "Der Autor ist im Bilde. Idee, Form und Geschichte des Dichter- und Gelehrtenporträts", in *Jahrbuch der Deutschen Schillergesellschaft*, ed. Wilfried Barner, Christine Lubkoll, Ernst Osterkamp, Ulrich Raulff, Göttingen: Wallstein, vol. 51, 2007, p. 551–586. Diers sees in the portrait of Kracauer, with which he ends his article, significant correspondences with a woodcut of Petrarch of 1532 which influenced the representation of authors, but he attributes this to pure chance.

23 S. Kracauer, "Anmerkung über Porträt-Photographie", in *Werke. Essays, Feuilletons, Rezensionen*, ed. Inka Mülder-Bach, Berlin, Suhrkamp, vol. 5.4 (1932–1965), 2011, p. 361 (trans.: "A Note on Portrait Photography", pp. 59–61 of this volume).

24 The Kracauers passed the summers of 1952, 1953 and 1955 on Lake Minnewaska in New York State.

25 See S. Kracauer, "Tentative Outline of a Book on Film Aesthetics" (1949), in *Siegfried Kracauer — Erwin Panofsky Briefwechsel 1941–1966*, ed. Volker Breidecker, Berlin, Akademie Verlag, coll. Schriften des Warburg-Archivs im Kunstgeschichtlichen Seminar der Universität Hamburg, 1996, p. 84: "Film is not photography: the 'shot' — the smallest unit of a film — completely absorbs the snapshots ('picture frames') of which it consists."

26 Maya Deren, born Eleonora Derenkowsky in 1917 in Kiev, died in October 1961 in New York. In 1948, in a review of a number of films, Kracauer

commented on three of her films, describing them as the best known of an avant-garde movement then forming in New York, S. Kracauer, "Filming the Subconscious", in *Siegfried Kracauer's American Writings*, ed. Johannes von Moltke and Kristy Rawson, Berkeley and Los Angeles: University of California Press, 2012, pp. 57–62. (trans.: "Die filmische Gestaltung des Unterbewußten", in *Werke. Kleine Schriften zum Film*, vol. 6.3, pp. 387–388. Deren's films are frequently mentioned in *Theory of Film* (1960).

27 After the plan of a first trip to Europe in 1955 did not materialise, the Bollingen Foundation, for which Kracauer worked as an expert, financed a stay of three months in Europe in 1956. There was a second trip to Europe in 1958. From 1960 on, Lili and Siegfried Kracauer spent the summer months in Europe every year, primarily in France and Italy, Germany and Switzerland. On this series of failed photos see Maria Zinfert (2013), "On the Photographic Practice of Lili and Siegfried Kracauer: Portrait Photographs from the Estate in the Deutsches Literaturarchiv (Marbach am Neckar)", in The Germanic Review: Literature, Culture, Theory, 88:4, pp. 435–443.

28 S. Kracauer, *History. The Last Things Before the Last*, New York, Oxford University Press, 1969 (reprint Princeton: Markus Wiener, 1995).

29 See Theodor W. Adorno / Siegfried Kracauer, *Briefwechsel 1923–1966*, pp. 449; "the past revisited" is in English and "time regained" in French in the original letter to Adorno of the 1st October 1950, in which Kracauer announces to his friend, among other things, the publication of his essay "The Photographic Approach" *in Magazine of Art*, vol. 44, No. 3, March 1951, p. 107–113 (p. 63–67 of this volume).

Sources of the Texts

"Die Photographie"
(*Frankfurter Zeitung*, 28th October 1927), in Siegfried Kracauer, *Werke. Essays, Feuilletons, Rezensionen*, ed. Inka Mülder-Bach in collaboration with Sabine Biebl, Andrea Erwig, Vera Bachmann and Stephanie Manske, Berlin: Suhrkamp, vol. 5.2 (1924–1927), 2011, pp. 682–698.

"An der Grenze des Gestern. Zur Berliner Film- und Photo-Schau"
(*Frankfurter Zeitung*, 12th July 1932), in Siegfried Kracauer, *Werke. Kleine Schriften zum Film*, ed. Inka Mülder-Bach in collaboration with Mirjam Wenzel and Sabine Biebl, Frankfurt am Main: Suhrkamp, vol. 6.3 (1932–1961), 2004, pp. 76–82.

"Photographiertes Berlin"
(*Frankfurter Zeitung*, 15th December 1932), in Siegfried Kracauer, *Werke. Essays, Feuilletons, Rezensionen*, vol. 5.4 (1932–1965), 2011, pp. 310–312.

"Anmerkung über Porträt-Photographie"
(*Frankfurter Zeitung*, 1st February 1933), in Siegfried Kracauer, *Werke. Essays, Feuilletons, Rezensionen*, vol. 5.4 (1932–1965), 2011, pp. 359–361.

"The Photographic Approach"
(*Magazine of Art*, vol. 44, No. 3, 1951, pp. 107–113), reprinted in *Siegfried Kracauer's American Writings. Essays on Film and Popular Culture*, ed. Johannes von Moltke, Kristy Rawson, Postface by Martin Jay, Berkeley: University of California Press, 2012, pp. 204–213.

Philippe Despoix, "Kracauer Penseur du médium photographique",
in Siegfried Kracauer, *Sur le seuil du temps, Essais sur la photographie*,
Texts chosen and presented by Philippe Despoix, Montréal: Les Presses
de l'Université de Montréal, Paris: Editions de la Maison des sciences de
l'homme, 2013, pp. 7–24.

Maria Zinfert, "Curriculum Vitae in Pictures",
in Siegfried Kracauer, *Sur le seuil du temps, Essais sur la photographie,* ibid.,
pp. 83–107.

List of Illustrations and Photographic Credits

Kracauer as Thinker of the Photographic Medium

Ill. 1. Drei Jahre Tillergirls in Berlin [Three Years of Tiller Girls in Berlin], *Berliner Illustrirte Zeitung*, No. 43, 1927, p. 1739; repro. Deutsches Literaturarchiv Marbach (DLA).

Ill. 2. Keine Puppengesichter mehr! Individuelle Film-Schönheit [No More Dolls' Faces! Individual Beauty at the Cinema], *Berliner Illustrirte Zeitung*, No. 45, 1927, p. 1827; repro. DLA.

Ill. 3. André-Adolphe-Eugène Disdéri, Portrait No. 3 taken from *Mlle Hortense Schneider en huit poses* [Miss Hortense Schneider in Eight Poses], 1860; albumen print, 10 x 6 cm, Musée d'Orsay, Paris; Photog. Hervé Lewandowski, RMN-Grand-Palais / Art Resource, NY.

Ill. 4. Von Hindenburg, cover of the *Berliner Illustrirte Zeitung*, No. 40, 1927; repro. Bayerische Staatsbibliothek.

Ill. 5. Die neue Silhouette. Die Berliner Golfspielerin Frl. Tag beim Driveschlag [The New Silhouette. The Berlin lady golfer Miss Tag hitting a drive], cover of the *Münchner Illustrierte Presse*, No. 30, 1927; repro. Bayerische Staatsbibliothek.

Ill. 6. Zeiss-Ikon advertisement, *Berliner Illustrirte Zeitung*, No. 14, 1927, p. 541; repro. Staatsbibliothek zu Berlin.

Ill. 7. Agfa advertisement, *Berliner Illustrirte Zeitung*, No. 29, 1927, p. 116; repro. DLA Marbach.

Ill. 8. Bioscope of the Skladanowsky brothers, 1895; Filmmuseum Potsdam, photograph Klaus Bergmann.

Ill. 9. Film roll taken from the first film by the brothers Max and Emil Skladanowsky, 1895; Bundesarchiv Bild 183-C31914.

Ill. 10. Albert Vennemann, *Blick auf die Kaiser-Wilhelm-Straße Richtung Lustgarten* [View on Kaiser-Wilhelm Street in the direction of the Lustgarten], ca. 1925, original paper print, 9.5 x 14.2 cm; Stadtmuseum Berlin.

Ill. 11. Eugène Atget, *Rue Saint-Rustique*, 1922; Digital Image, The Museum of Modern Art, New York / Scala, Florence.

Photography

Front page of the *Frankfurter Zeitung*, 28th October 1927; repro. Staatsbibliothek zu Berlin.

On Yesterday's Border

Front page of the *Frankfurter Zeitung*, 12th July 1932 (detail); repro. Staatsbibliothek zu Berlin.

Photographed Berlin

Front page of the *Frankfurter Zeitung*, 15th December 1932 (detail); repro. Staatsbibliothek zu Berlin.

Note on Portrait Photography

Front page of the *Frankfurter Zeitung*, 1st February 1933 (detail); repro. Staatsbibliothek zu Berlin.

The Photographic Approach

P. 62 Fox Talbot, *The Open Door,* taken from *The Pencil of Nature,* 1844 (courtesy of Beaumont Newhall); facsimile page of *Magazine of Art,* vol. 44, No. 3, 1951, p. 107.

P. 65 Antony Samuel Adam-Salomon, *Self-Portrait,* ca. 1860 (Eastman Historical Photographic Collection); *Magazine of Art,* p. 108.

P. 70 Edward Weston, *Rock Erosion,* 1935 (collection Museum of Modern Art); *Magazine of Art,* p. 109.

P. 71 Laszlo Moholy-Nagy, *From Berlin Wireless Tower,* 1928 (collection Museum of Modern Art, courtesy of Sibyl Moholy-Nagy); *Magazine of Art,* p. 109.

P. 72 Henri Cartier-Bresson, *Children Playing in the Ruins, Spain,* 1933 (collection Museum of Modern Art, courtesy of Magnum Photos, Inc.); *Magazine of Art,* p. 110.

P. 73 A. J. Russell, *Granite Canyon in Foreground,* 1867 (collection Museum of Modern Art); *Magazine of Art,* p. 111.

P. 75 Eliot F. Porter, *Road Runner,* 1941 (collection Museum of Modern Art, courtesy of the photographer); *Magazine of Art,* p. 112.

P 77. Eugene Atget, *Tree Roots,* ca. 1915 (collection Museum of Modern Art, courtesy of Berenice Abbott); *Magazine of Art,* p. 113.

Curriculum Vitae in Pictures

Ill. 1. Frankfurt am Main, 1897, Atelier Collischonn; paper print on cardboard, 6.5 x 10.5 cm; Kracauer estate (KE), Deutsches Literaturarchiv Marbach (DLA).

Ill. 2. Frankfurt am Main, 1904, Atelier Erna; paper print on cardboard,11.5 x 5.5 cm; KE DLA.

Ill. 3. Italy [?], ca. 1912, unknown photog.; paper print of the reproduction of an identity photo, 26 x 20 cm; KE DLA.

Ill. 4. Mainz, 1917, unknown photog.; paper print on cardboard, 8.7 x 13.6 cm; KE DLA.

Ill. 5. Frankfurt am Main [?], the 1920s, unknown photog.; original paper print, 8.5 x 12.5 cm; KE DLA.

Ill. 6. Dolomites (Italy), 1924, unknown photog.; original paper print with pencil marks, 9 x 13.5 cm; KE DLA.

Ill. 7. Frankfurt am Main, second half of the 1920s, unknown photog.; paper print from the archive (DLA) of a broken glass negative, 17 x 12 cm; KE DLA.

Ill. 8. Paris [?], 1930, photog. Elisabeth Kracauer; original paper print, 14 x 9 cm; KE DLA.

Ill. 9. France, ca. 1934, unknown photog.; original paper print, 5 x 8 cm; KE DLA.

Ill. 10. Combloux (Haute-Savoie), 1934, photog. Elisabeth Kracauer; original paper print, 9 x 14 cm; KE DLA.

Ill. 11. Combloux (Haute-Savoie), 1934, photog. Siegfried Kracauer; paper print from the archive (DLA), 12 x 17 cm; KE DLA.

Ill. 12. Card issued to Kracauer as a journalist of the *Neue Zürcher Zeitung* 1937, unknown photog.; original document, 10 x 13 cm; KE DLA.

Ill. 13. Frankfurt am Main, ca. 1938, unknown photog.; original paper print, 8.5 x 11.5 cm; KE DLA.

Ill. 14. Stamford (New York), 1950, photog. Elisabeth Kracauer; original paper print, 12 x 8 cm; KE DLA.

Ill. 15. Lake Minnewaska (New York), first half of the 1950s, photog. Elisabeth Kracauer; original paper print, 8 x 5 cm; KE DLA.

Ill. 16. New York, second half of the 1950s, unknown photog.; Polaroid, 6 x 8 cm; KE DLA.

Ill. 16a. Back of the Polaroid with handwritten notes and the stamp of the archive; KE DLA.

Ill. 17. Klosters (Switzerland), 1960, photog. Elisabeth Kracauer [?]; taken from a contact sheet in the archive (DLA) of the original Kodak film roll; KE DLA.

Ill. 17a. Klosters (Switzerland), 1960, photo No. 29 of the same contact sheet, 4 x 3.5 cm; KE DLA.

Ill. 18. Rome, 1964, photog. Elisabeth Kracauer; original paper print, 17.5 x 11 cm; KE DLA.

Acknowledgements

We would like to thank all those who have contributed to this publication, first of all, the Presses de l'Université de Montréal and the éditions de la Maison des sciences de l'homme in Paris for giving us permission to use the concept of a collection of essays of Kracauer on photography which first appeared in a French edition entitled *Le Seuil du temps* (2013). We would also like to thank Conor Joyce who translated the texts always in a spirit of friendly collaboration.

We are also grateful to the Deutsches Literaturarchiv Marbach am Neckar and to its very cooperative staff, above all in the photographic archives.

The support of Pascal-Anne Lavallée and of Jean-Philippe Michaud – for additional research, the preparation of materials and bibliographical harmonisation – was decisive, as was the support of the Canadian Centre for German and European Studies (Montreal) which generously subsidised the research necessary for the book.

We also thank Nia Perivolaropoulou for her remarks and suggestions, absolutely invaluable as always, during the preparation of this collection.

© diaphanes
Zurich-Berlin 2014
ISBN 978-3-03734-691-4

www.diaphanes.com

Typedesign: 2edit, Zurich
Cover image: Siegfried Kracauer, Stamford (N.Y.) 1950,
photog. by Elisabeth Kracauer, detail of original contact print,
Kracauer Estate, Deutsches Literaturarchiv Marbach
Printed in Germany